Vintage Collage
for Scrapbooking

Collage… the newest, hottest trend!

*Tons of ideas to inspire you to create
a collage scrapbook filled with transfers,
embellishments, transparencies,
tags, textures, ephemera and more….*

by
Jill Haglund

With artists: Roben–Marie Smith & Joey Long

TweetyJill
PUBLICATIONS
makes you creative!

Acknowledgments

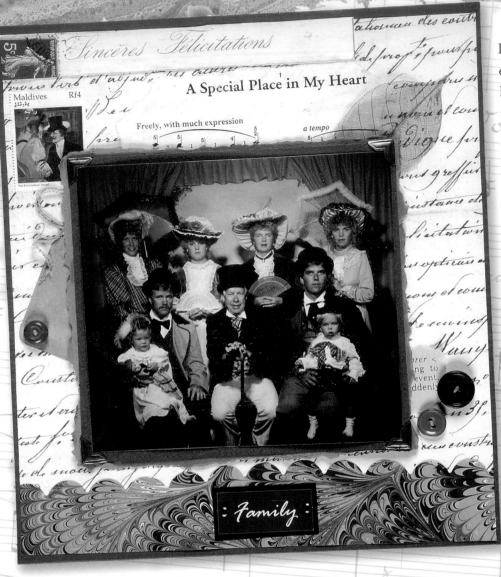

A Special Place in My Heart

Freely, with much expression

Family

I want to thank my entire extended family for their love and encouragement throughout this project; without them I would not have the wonderful memories I so cherish. I am especially grateful to my teenagers, Lindsay, Matthew and Jason for their unwavering support. They *each* express their own forms of creativity through music, art or sports, and have patiently understood and cheerfully allowed me the time necessary to write this book. An extra special thanks to my husband, Rob, who always believes in me and trusts my insights! His input is invaluable. As my partner and CEO of TweetyJill Publications, he oversees all aspects of the business and helps make each TweetyJill book title better than the last.

I also wish to express my heart-felt appreciation to artists Roben-Marie Smith and Joey Long for the talent they have willingly shared and brought to this project. Their work inspires the viewer and gives special meaning to creating Vintage Scrapbooks. They shine like stars throughout the publication.

Thanks to Laurie the designer, for her creative vision in magically transforming the book to one of beauty and class. Thanks to Lisa, the patient and determined editor who sprinkled her "magic fairy dust" over the words and made them come alive. I am forever grateful to both of them for their hard work, continued encouragement and wonderful suggestions.

Most of all, I thank my God, who bestows all gifts and talents. He alone allows us the privilege to enjoy life and the capacity to relish the memories.

And I thank you, the reader, for buying this book! You are about to embark on a scrapbook journey that is very fulfilling indeed. We know you'll have as much fun along the way as we did!

This book is dedicated to you all!

ARTISTS' BIOGRAPHIES

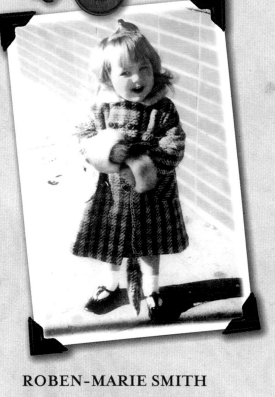

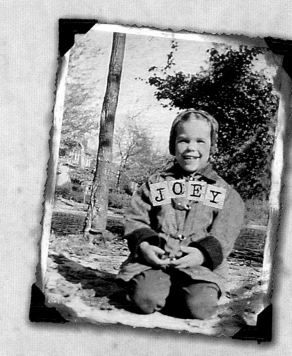

ROBEN-MARIE SMITH

Roben-Marie is a mixed media, collage and book artist and full-time instructor. She is the owner of Paperbag Studios, which boasts a quarterly subscription-based club called Club Fragments. It is a club for collage, mixed media and book artists who want good stuff! Each quarter features a blend of original ephemera as well as quality color collage sheets.

Paperbag Studios also features a line of un-mounted stamps. These stamps include alphabets, vintage photos, ephemera and some of Roben-Marie's own design. Visit her web site at: www.paperbagstudios.com.

Her work has been published in Somerset Studio, Stamper's Sampler, Legacy, PLAY Zine, ARTitude Zine, Altered Books 101 by Design Originals and the 2004 Somerset Studio Art Journal Calendar.

She lives in Port Orange, Florida with her very supportive husband, Bobby.

JOEY LONG

Joey is an artist and teacher at Keeton's Office and Art Supply in Bradenton, Florida. Over a period of seven years she has developed the Paper and Stamping Arts Department into a destination!

Her obsession with the arts has necessitated a move from an extra bedroom at home, to her own art studio in an old hotel rescued from obscurity by a wonderful landlord and a handful of dedicated artists.

She teaches stamping, lettering, book arts (altered and otherwise) and various mixed media projects. Her work has been published in Somerset Studio, The Gallery, vol. 1 and 3, Return to Asia and Rubber Stamper.

Her motto: *"As long as you realize you are not creating alone, the flow cannot be stopped."*
- Sarah Ban Breathnach

A NOTE FROM THE AUTHOR

I actually remember this moment in my life very well! I was about six years old, and recall asking my mother when she was putting in the garden in the Spring, if I could plant pumpkin seeds, grow a pumpkin and make pumpkin pie? Well...Guess what? That's exactly what we did. Here I am standing on my "homegrown-pumpkin", feeling on top of the world! Somewhere there is a snap shot of me with the pie, very proud, indeed!

PUMPKIN PIE
Jill Haglund

YESTERDAY

Just the other day, I was thinking about my life-long obsession with photographs and I asked myself, why? I finally recalled my first memory of the excitement of having a camera in my hand. I was about seven years old and it was our Kodak Brownie box camera, called a "Hawkeye".

Our third grade teacher had the entire class join the Audubon Bird Society. We eventually went on a field trip, notebook in hand, to identify the birds we had learned to recognize. Our teacher said we were welcome to bring a camera, as long as we had permission from our parents.

It was my lucky day! I was allowed to use the family camera to take pictures of the birds, which I carefully organized, labled and glued in one of my first scrapbooks. I still remember the exhilaration of peering through the lens and pressing that shutter button myself! I don't remember if the photos were good, but I thought they were. I believe most of them were of trees - or rather - blurred, bare branches, but to me, they were marvelous treasures.

Right about that time my mother introduced me to film processing. She had a darkroom in our cellar and encouraged me to watch and learn from her. I was making prints from negatives by the time I was seven or eight. That's when I knew that photography, and showcasing my snapshots, would be my life-long passion.

After all of this reminiscing, I decided to poke around eBay, and guess what? Right in front of my eyes was an old "Brownie Hawkeye." Hmmm, just to touch it again, I thought, and it was just a few dollars … Well, I won the bid and now have my very own!

TODAY

As I was looking over our family's old photographs one day, I found myself mysteriously drawn to them. Some were black and white snapshots; others were sepia-toned. There were photos of my parents, me and my siblings when we were very young, and of family members from two and three generations ago. I was flooded with memories and reminded of stories I'd been told. Of course, I didn't know everyone in the photos, but I wanted to. These old images intrigued me. But somehow in my "scrapbooking frenzy" over the years, I overlooked them.

I resolved to place these precious pictures where my children's, children's children could see them, read about them, and feel the presence today of their relatives from generations past; to do something new and different, so they would be never again be forgotten. That is how "Vintage Collage for Scrapbooking" came to be.

TOMORROW

You've probably got a few scrapbooks of your own … lovely reminders of vacations, special moments, of your children when they were small. But consider reviewing your own baby pictures and your mother's, or photos from when she was a teen. Maybe you have an old photograph of your grandfather when he was at work, or of your great-grandmother rocking her babies to sleep.

You can do something different with these photos - something that never gets dated; that not only reflects a time period, but also transports you there with visual remnants of the distant past. The pages of your scrapbook will last a lifetime, full of collage and embellishments. Your children and theirs will want to know their history. You may be the only one to tell them.

Here's to your beautiful yesterdays, todays and tomorrows …

Jill Haglund
Founder and President of TweetyJill Publications

*Author of: The Complete Guide to Scrapbooking,
The Idea Book for Scrapbooking,
Scrapbooking for Kids (ages 1-100),
Scrapbooking As a Learning Tool and
Vintage Collage for Scrapbooking*

TABLE OF

1 Vintage Collage Ephemera & Acid-Free Scrapbooks

Page 8

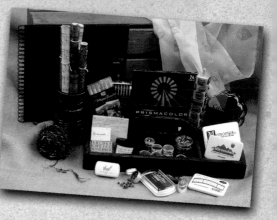

2 Toolbox, Materials & Adhesives

Page 14

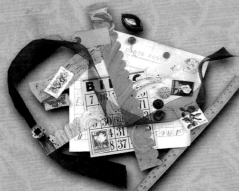

3 Time to Collage

Page 20

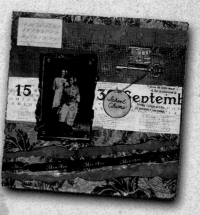

4 Eyelets, Snaps, Brads & Photo Turns

Page 30

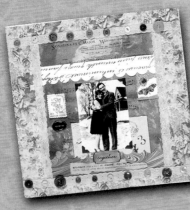

5 Buttons, Ribbon & Lace

Page 40

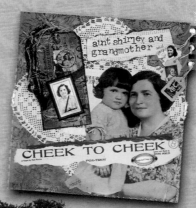

6 Tag, You're It!

Page 48

CONTENTS

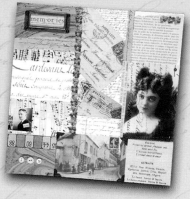

The Key to
Transparencies
Page 56

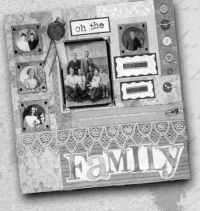

Framed
Page 68

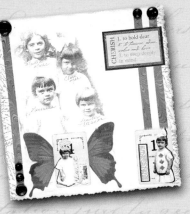

How To Do
Transfers
Page 72

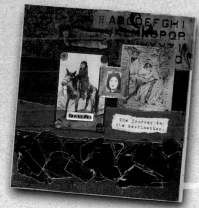

Textures: Fabric,
Fibers, Mica, Mesh
& More
Page 78

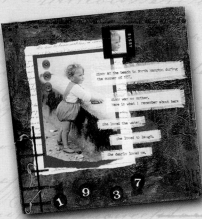

Creative Ways
With Words
Page 90

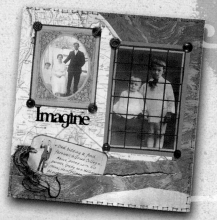

A Journey
Through
the Gallery
Page 103

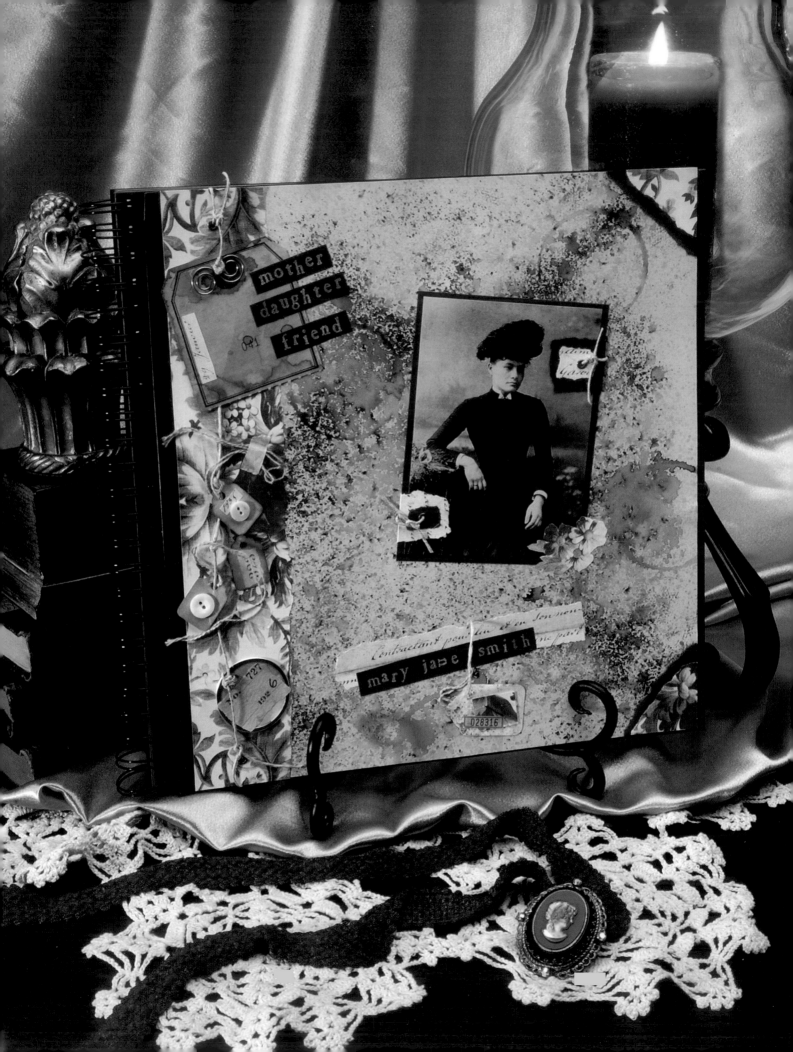

The moment you stroll down the aisle of your local craft and scrapbook store – with the thought of creating your first vintage collage scrapbook – you will see you are beginning a glorious journey!

You'll encounter papers in rich brocade patterns, authentic vintage French and Italian scripts, beautiful lifelike embossed vellum leaves and floral patterns, old maps, vintage alphabet fonts, antique letters, numbers and school lesson plans. Music, vintage newspapers, ledger pages and elegant peacock, feathered and stone-patterned marbles in a multitude of colors – even tissue papers … all begged to be touched. You'll discover replicated sewing patterns, antique clothes, game pieces and textbook pages.

Dimensional materials and embellishments are just as plentiful. Metal and pewter frames, letters, tags and adhesive embellishments that go far beyond the term "sticker," enhance and frame your scrapbook page. Transparent, white and black plastic typewriter fonts and words pressed into metal discs bring to life the voices of your past.

The art of creating vintage collage scrapbooks is spreading like wildfire! It's no wonder there are so many companies with products to fuel our passions. K&Company, Design Originals, 7 gypsies, Anna Griffin, Paper Passions, Frances Meyers, Paper Pizazz, Daisy D's. Angy's Dreams, Pebbles, Inc., Rusty Pickle and Making Memories are just a few that offer lines of papers and materials to meet the rapidly growing demand.

Shop 'til you drop, but don't stop when you drop! Once you've relished seeing, touching and feeling the wide selection of collage items available in stores, hop on the Internet for "genuine" vintage items. Find them at websites www.vintagecharmings.com, www.foundelements.com, and www.collagejoy.com, to name just a few.

Vintage scrapbook collage is all about combining these wonderful papers and materials with your own photographs and mementos.

For instance, you may be lucky enough to own an old letter with a stamped envelope written in your great aunt's handwriting, a newspaper clipping, canceled check, ticket from when your relatives came to America, your great grandfather's military records or even a jar of your grandma's buttons. You may want to use some favorite quotes, poems or Bible verses copied onto coffee-dyed paper. (See directions for coffee-dyed paper in Chapter 3.) Vintage collage ephemera – papers and objects with dimension – add a richness and depth to your scrapbook and can transform it into a work of art that will still be interesting and beautiful 100 years from now.

WORD OF WARNING: Once you become comfortable with collage, you will most likely get hooked on seeking out ephemera and good "junk." Your new obsession will lead you to antique shops, garage sales and flea markets. You will gush over items like old sheet music, calendars and timetables, theater programs, maps, vintage penmanship books, coupons, postcards, bingo cards, perfume labels, report cards, tickets, receipts and certificates. Foreign language textbooks and old elementary, high school and college textbooks will hold new value. You will find yourself buying items you never dreamed of for your scrapbooks, such as shipping tags, eyelets and fabric swatches.

NOTE: There is a growing reluctance to incorporate into collage any items that are not acid-free. With the term "acid-free" being the buzzword for so many years, allow me to present you with a "Certificate of Free Expression!" If you use the papers and materials we recommend in this publication, and do not let any metal or other questionable element come into direct contact with an original photograph, your page will be acid-free. This means longevity for your scrapbook, no fading colors, yellowed papers, or brittle, cracked edges a few years down the road. Even though your pages will be safe from deterioration, we suggest you simply do not use original photographs for a heritage scrapbook; make copies to use instead. Doing so allows you the most creative freedom. Experiment, play and dance around the photos in your collage with whatever you want!

> You are limited only by your imagination … let it run wild!

VINTAGE COLLAGE EPHEMERA & ACID-FREE SCRAPBOOKS

LEGACY
Roben-Marie Smith

MATERIALS:

CARD STOCK: MAKING MEMORIES

KEY AND "LEGACY" PLATE: LI'L DAVIS DESIGNS

CHARM CORNERS: LOCAL CRAFT STORE

ADHESIVES: ALEENE'S TACKY GLUE; UHU GLUE STICK

OTHER: TRIM, FABRIC, RICKRACK, BUTTONS, SCRIPT PAPER

INSTRUCTIONS:

Layer card stock and old script paper to page. Sew fabric pieces together and layer to page. Glue on photo and add charms to each corner. Glue trim to page as shown. Glue rickrack, buttons, key and "legacy" plate to page.

[CREATIVE TIP] ▶

Mesh, cutout photos and three-dimensional objects like buttons, a game piece and a key; who knew that combining these common items would result in such an extraodinary layout. Don't worry about where to journal, just use the next page.

MARY JANE SMITH
Roben-Marie Smith
(Shown on page 8)

INSTRUCTIONS:

Sprinkle walnut ink granules onto card stock and spritz with water. Randomly place mugs on top to create rings; let dry. Add a strip of brown card stock and torn pattern paper to the left side of the page. Add eyelets to the top and bottom of the pattern paper. Tie twine through the eyelets. Add tags and gold spiral before making the final knot. Embellish tags with paper ephemera, buttons and stamped strips of card stock. Add torn brown card stock and pattern paper to the top and bottom right-hand corners. Add torn card stock and script paper to photo and set with eyelets. Tie twine through the eyelets and glue to page. Add torn strip of script paper below the picture, stamp brown card stock strip with white ink and glue to page. Staple a piece of pattern paper and ephemera to medium white tag and glue to page.

MATERIALS:

FLORAL PATTERN PAPER: ANNA GRIFFIN

EYELETS AND METAL SPIRAL: MAKING MEMORIES

TAGS: OFFICE SUPPLY

WALNUT INK (IN GRANULAR FORM): POSTMODERN DESIGN

PHOTOGRAPH AND PAPER EPHEMERA: PAPERBAG STUDIOS

RUBBER STAMPS: PERSONAL STAMP EXCHANGE (PSX)

BLACK INK: INKADINKADO

ADHESIVES: YES! PASTE; UHU GLUE STICK

OTHER: BUTTONS, TWINE, CARD STOCK, SCRIPT PAPER

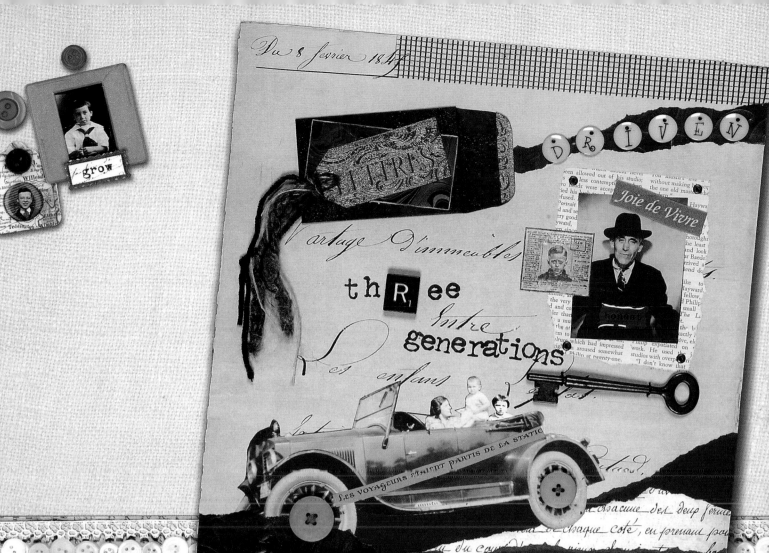

MATERIALS:

LETTERS STAMP: RUBBER MONGER

ALPHABET BUTTONS: JUNKITZ

PAPER COIN POCKETS: SKYCRAFT STUDIOS

ALPHABET & LITTLE BOY RUBBER STAMPS: PAPERBAG STUDIOS

EMBOSSED PAPER: ANNA GRIFFIN

BROWN PAPER: CANSON "TOBACCO"

FRENCH WORD PAPER & "JOIE DE VIVRE" RIBBON: THE CREATIVE BLOCK

MESH: MAGIC MESH

OLD KEY: STAMPINGTON & COMPANY

BUTTONS: STICKO "BUTTON UPS"

BUBBLE WORD: K&COMPANY

EYELETS: MAKING MEMORIES

ADHESIVES: THE ULTIMATE! GLUE; YES! PASTE; UHU GLUE STICK

OTHER: FIBERS, GAME TILE PIECE, WAXED LINEN THREAD, HAND MADE PAPER, SCRIPT PAPER

INSTRUCTIONS:

Copy black and white photo of little girl and enlarge sepia-toned car photo. Glue background onto page, layer strips of other papers as shown, in a downward direction. Cut out car and one little girl from the other photo and place her in the car. Paste car to page, festooning wheels with buttons. Cut out sentence from French word paper and glue across car as shown. In upper right, glue square-shaped torn page from old book to use as a mat, add eyelets and glue on photo. Layer stamped little boy to left side of mat, glue "Joie de Vivre" ribbon at an angle. Add fibers to tag embossed with letters stamp, glue it to a rectangle of marbled paper and then onto a handmade paper envelope, embossed on end. Adhere it all to the page, angled upward. Glue down paper and "DRIVEN" buttons angled as shown. Add mesh to top of page; sew key to center with waxed linen thread, knotting in the back. Add game piece for the letter "R" in the word "thRee".

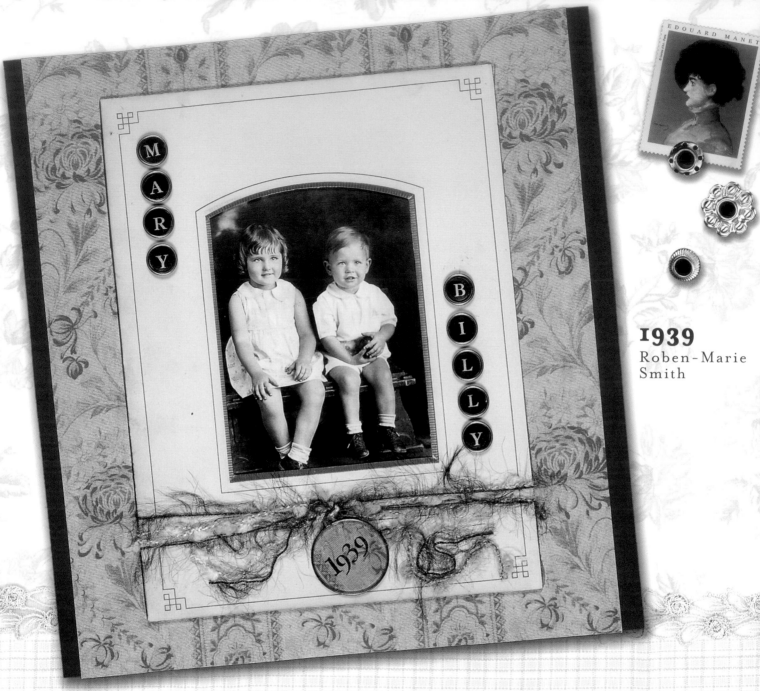

1939
Roben-Marie
Smith

MATERIALS:

PATTERN PAPER: ANNA GRIFFIN

CARD STOCK: MAKING MEMORIES

LETTERS AND COPPER DISCS: NUNN DESIGN

LENS: STAMPERS ANONYMOUS

FIBERS: ADORNMENTS

NUMBER RUBBER STAMPS:
PSX (PERSONAL STAMP EXCHANGE)

DYE INK: STAZON

ADHESIVES: ART ACCENZ STICKY TAPE,
YES! PASTE; JUDI KINS DIAMOND GLAZE;
GLUE DOTS INTERNATIONAL

OTHER: OLD PHOTO FRAME

INSTRUCTIONS:

Paste pattern paper to page. Place photo into old photo frame and wrap fibers around bottom. Tape frame to page. Stamp numbers onto cut piece of pattern paper and adhere to lens with glaze. Tie lens to fibers; use glue dots to adhere to page. Place letter stickers into copper disks and adhere to page with glue dots.

LOVE IS THE JEWEL

Roben-Marie Smith

MATERIALS:

PAPER: ANNA GRIFFIN

EYELETS:
MAKING MEMORIES

SAFETY PIN:
ANIMA DESIGN

**LETTER BEADS
AND TWINE:**
LOCAL CRAFT STORE

FLOWER: THE CARD
CONNECTION

ADHESIVES: THE
ULTIMATE! GLUE;
UHU GLUE STICK

OTHER: BUTTONS,
CANCELED CHECK,
LACE, RIBBON, TRIM,
TEXT PAPERS

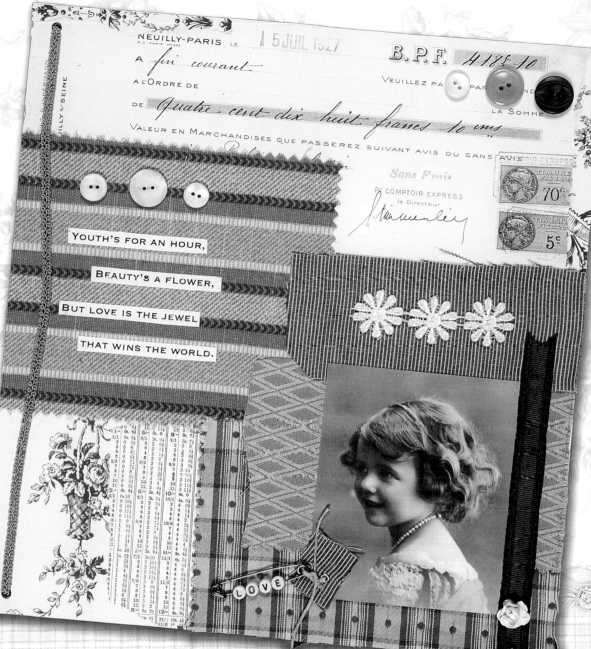

YOUTH'S FOR AN HOUR,

BEAUTY'S A FLOWER,

BUT LOVE IS THE JEWEL

THAT WINS THE WORLD.

INSTRUCTIONS:

Glue old check, text paper and pattern paper to page. Glue various fabric pieces to page as shown. Computer-generate quote and glue to page. Cut a small piece of fabric and set two eyelets; add twine and thread through safety pin. Add beads to pin and glue to page over corner of photo. Glue buttons, ribbon, flower and lace to page. Set eyelets at top left and bottom left of page; thread with trim.

The wonderfully elaborate layouts on pages 10 – 13 are examples of more advanced collage, but don't let the term "advanced" scare you. You'll feel comfortable and have fun assembling inspiring pages like these after you learn to follow along, one step at a time (Chapter 3 "Time to Collage!").

CHAPTER 2

remember

Whether you are building a deck, fixing an appliance, or yes, you guessed it, creating a scrapbook, it's all about having the right materials and tools! They free you to focus and enjoy the task at hand. You'll feel like a kid in a candy store when you see the latest gadgets and vintage-type page embellishments you'll be using. The thrill of a wonderful find, like a jar of vintage buttons for two dollars at a garage sale, combined with discovering a state-of-the-art eyelet setter, may actually cause your pulse to quicken!

YOUR TOOLBOX

It's tool time, and we are going to fill up your toolbox with the latest and greatest. If you are a scrapbook enthusiast, you may already have some of these items. Nonetheless, you may never have needed an Anywhere Punch, "set an eyelet" or placed a "photo turn" on your layout. A whole new world is about to open up to you!

ESSENTIALS:

Paper Trimmer

Small Wire Cutter

Transparent Square Ruler

Hammer or Rubber Mallet
for Setting Eyelets

Eyelet Setter for Various Size Eyelets

Mat for Setting Eyelets

Dymo Label Maker

Embossing Heat Tool

SCISSORS: Paper Adventures Mammoth Edge Accents Scallop Scissors and Fiskars Paper Edgers are perfect for cutting borders. Look for regular long-blade Softgrip scissors, small-tip scissors for extra tight cutting, and Non-Stick scissors for trimming sticky materials.

PUNCHES: Stock a variety for punching different size holes for eyelets, snaps and brads. You may want to label or color code each punch to reference the size hole it punches, so you can easily find what you need. The Anywhere Punch, works for a wide range of hole sizes and punches *anywhere* on a page.

TOOLBOX, MATERIALS & ADHESIVES

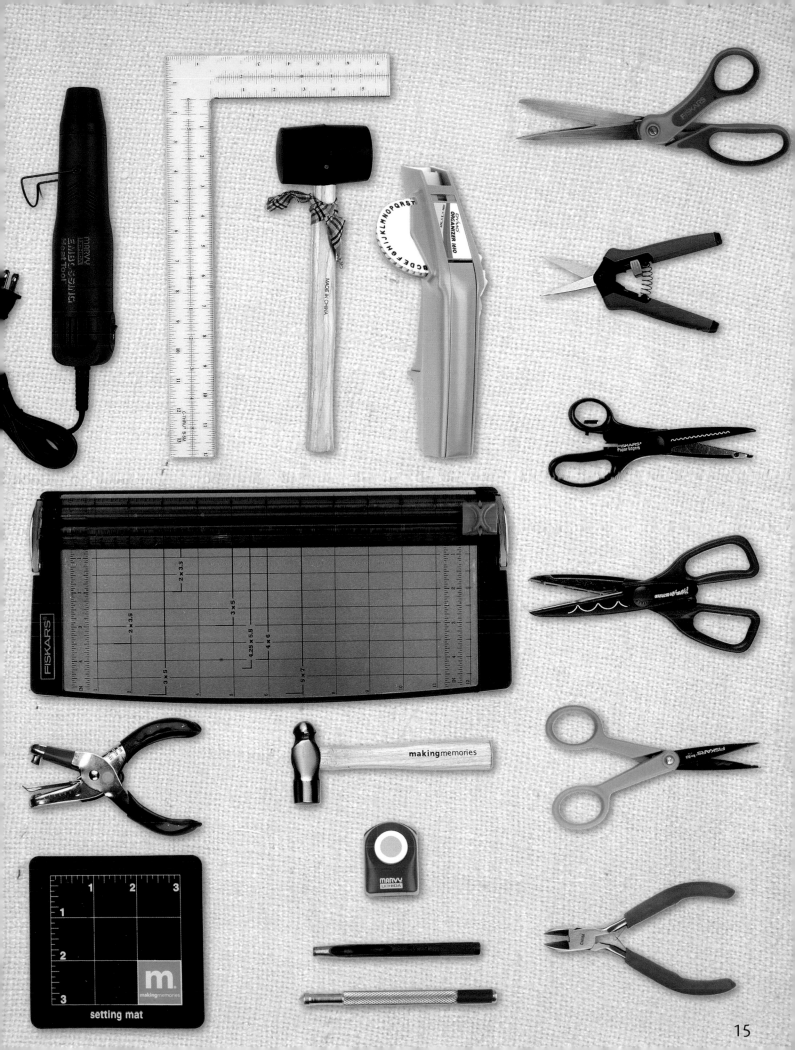

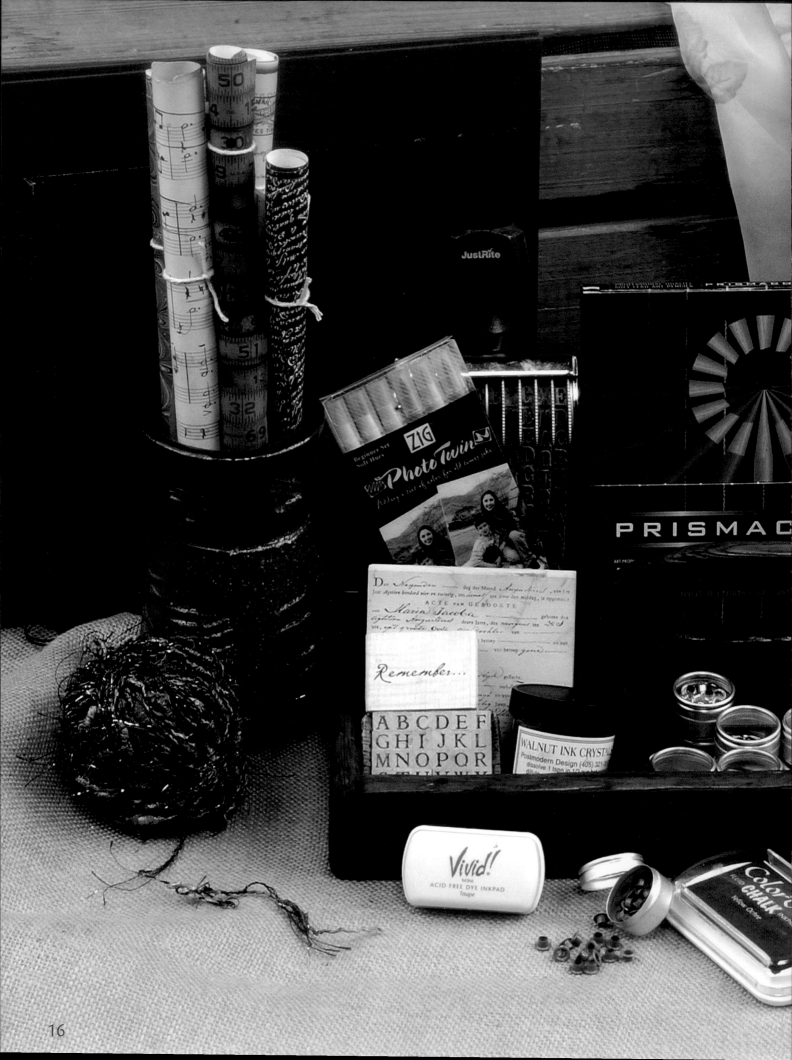

MATERIALS

You will mostly likely build your inventory slowly, as you see page layouts that inspire you.

Scrapbook of Your Choice

Assorted Scrapbook Papers including Various Script Papers, Card Stock, Textured Specialty Papers, Tags and Ephemera

Adhesives *(you will need a variety of types for different textures and weights of materials)*

A Good Quality, Reliable, Archival Pen in Black or Brown

Eyelets, Snaps and Brads in Various Colors, Shapes and Sizes *(for a vintage feel choose brass, copper, black, silver or gunmetal)*

Photo Turns in Brass, Silver and Black

Various Colors of Dye and Pigment Inks

Rubber Stamps *(especially letters and numbers)*

Shipping Tags in Various Sizes and Shapes

Walnut Ink *(granular form)*

Colored Pencils

Magic Mesh

A Variety of Fibers

Waxed Linen Thread

Photo Tinting Pens

Copper Mesh

Liver of Sulfur

Transparency Film Sheets *(for your home inkjet and for a commercial copier as well - you can read about each of the two types of film in Chapter 7)*

Instant Coffee *(to make coffee-dyed papers - see directions in Chapter 3)*

Other: Postage stamps, buttons, lace, old keys, game pieces, old metal book plates or metal file cabinet plates, safety pins, clips and other odds and ends.

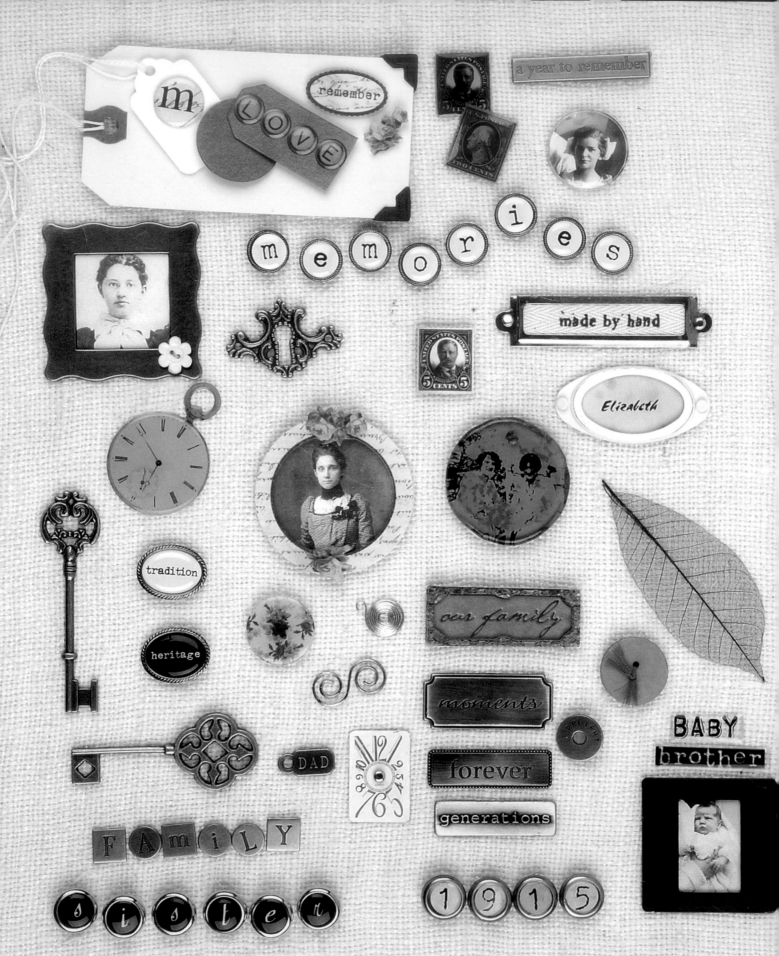

Here are a few of the specific products listed under "Materials" for each page layout. Most of these items are available at your local craft store. If you cannot find them, please refer to the Product Resource Guide for the website of a particular manufacturer, most provide names and locations of retailers that carry their products.

ADHESIVES

A word about specific adhesives and their uses.

Yes! Paste and Golden Gel Mediums work well for most papers and cutout photos. They are a little messy though, as you have to apply them with a hard, thin plastic applicator. But they dry nicely, very smooth and flat.

Many people prefer an acid-free glue stick, and there are plenty to choose from. You can easily see where you apply colored glue sticks, like the UHU stic and Elmer's Craft Bond. The former appears purple and the latter, blue, but both dry clear. Elmer's also makes a smaller glue stick that's handy for tight spaces. **NOTE:** When using paste or glue sticks, you absolutely MUST put heavy books or some weighty object on the scrapbook page while it is drying, so it will adhere well and look smooth (see Chapter 3, Step 5).

Use Provo Craft's Art Accentz Sticky Tape for photographs, papers, slides, coin pockets, pewter frames and messages. Scotch Permanent Double Stick Tape or Kolo's Adhesive Tape are both good on photos and lightweight papers, and are easy and quick to use for layering papers for a mat around a picture. Scotch Masking Tape, torn in little pieces, holds tag string in place. For creating dimension, just add a small piece of adhesive-backed foam. Glue Dots International and PEELnSTICK ZOTS Clear Adhesive Dots are an excellent choices for buttons and small metal pieces. You can use The Ultimate! glue for most objects, but apply sparingly on papers so they won't buckle. Diamond Glaze, Aleene's Tacky Glue, Perfect Paper Adhesive and E-6000 are great for mica and holding anything multi-dimensional.

If you don't already own a Xyron machine, consider buying one (see photo below). It is a wonderful tool for adhering just about anything. Any remaining sticky edges clean up easily with Adhesive Pick-up.

Lets get started!
We'll take it one step at a time.

Step 1

SELECT YOUR PHOTO(S)

Vintage photographs have different tones; a subtle variety of shades or color values such as yellow, grey, brown, or even blue or pink. Once you have selected one to three photos to work with, closely observe their tones; they may influence the colors you choose for your layout. Unify your page with harmonious colors.

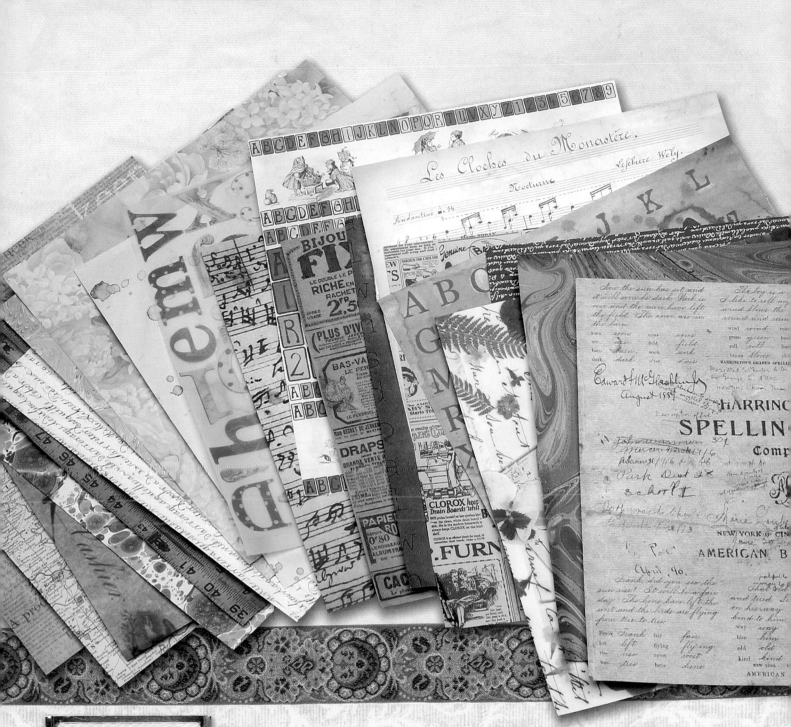

CHOOSE YOUR BACKGROUND

Start with a blank scrapbook page and look through your paper selection for a background to begin your collage. You may want to use a 12" by 12" paper all by itself or layer it with cut or torn coordinating papers.

Note: Don't forget! You may want to look through your card stock to find matching colors to cut or tear mats for your photographs.

[CREATIVE TIP]

Loosen up! Collage is an unusual and creative way to express yourself that is both pleasurable and reward-ing. If it is new to you, keep in mind that the items you select for your page need not be perfect. The following definition of collage may help: "Collage: pasting pieces together, possibly in an incongruous relationship for an effect." Incongruous means "lacking harmony or agreement, having inconsistent parts or elements, not corresponding to what is right, proper or reasonable." Now, with that in mind, put on some music, relax, and have fun ... anything goes!

21

ADD OTHER MATERIALS *

Once you have selected your basic background pieces, take your time choosing additional elements. Ponder over items that appeal to you and that you find interesting. Also, consider the texture, color or sentimental value of items you choose. These materials can add more feeling to your page. Think about using grandma's original, tattered sugar cookie recipe card, an old postcard, a page of your mother's favorite sheet music or a small frame for showcasing part of a photograph. Don't forget

to take a look at the wonderful vintage-style products available on the market. They will ensure your pages have an authentic look of antiquity. The color of the paper can help you decide upon ephemera such as postage, buttons or ribbon. Initially, you might want to use a limited amount of materials to feel successful.

** Going beyond step two is optional. The papers are sophisticated and elegant in themselves. For example, you may want to use a 12" x 12" French script paper or a marbled paper just the way it is, or simply add a few torn pieces of coffee-dyed sheet music and postage stamps.*

[CREATIVE TIP]
Taking your time does not mean obsessing over your choices. It means enjoying the experience! Perfectionism blocks your creativity.

PLAY WITH THE PIECES

Get whimsical! Arrange and rearrange the pieces onto your background. Try placing them at different distances from each other; "dance" them and around and around. Step back and take a look, checking for color and balance. NO GLUE YET.

Balance refers to weight; if you place a piece on one corner, you may need another one on the opposite side. You can also achieve balance with color and size.

Once you are satisfied with your composition, you are ready to glue and flatten.

GLUE, FLATTEN, DRY!

Commitment time! Review the items you are gluing and decide on the appropriate types of adhesive. For larger papers, choose Art Accentz Sticky Tape, a double-sided adhesive. It's fabulous! But, once it is down, it's there to stay; there is no repositioning! If you are working with a small piece or a cut-out or torn edge, try a glue stick or paste. Scrape paste on with an old credit card, applying a thin layer completely over the paper. If you are working with moist adhesives such as these, you must dry your page flat, particularly if you plan to add dimensional elements. When you are finished, tear two sheets of waxed paper the size of your page. Lay one sheet on top of your page and the other on the bottom and place under heavy items, such as a few books, to dry overnight.

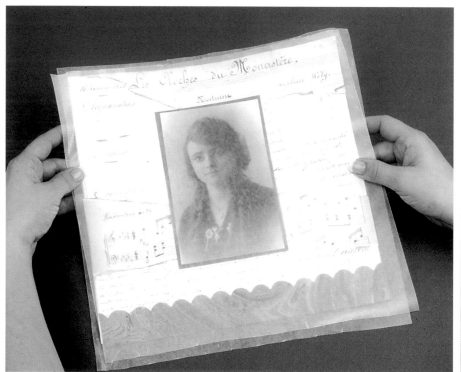

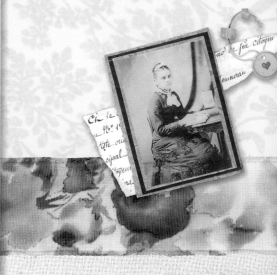

First, tear two pieces of wax paper to fit the pages and cover them carefully, so as not to disturb the work you have done.

Next, carefully place the page under a few heavy books and dry. Now you're ready for embellishments and three dimensional pieces.

ADD EMBELLISHMENTS

After your page has thoroughly dried and is as flat as possible, you may add any three-dimensional collage embellishments. This is where the real fun begins!

The Ultimate! Glue and Glue Dots are very effective for adhering items such as buttons, Page Pebbles, Ribbon Charms and Label Holders. Art Accentz Sticky Tape is best for pewter frames and bulky tags or fabrics. You'll discover your own favorite adhesives as you experiment with different types.

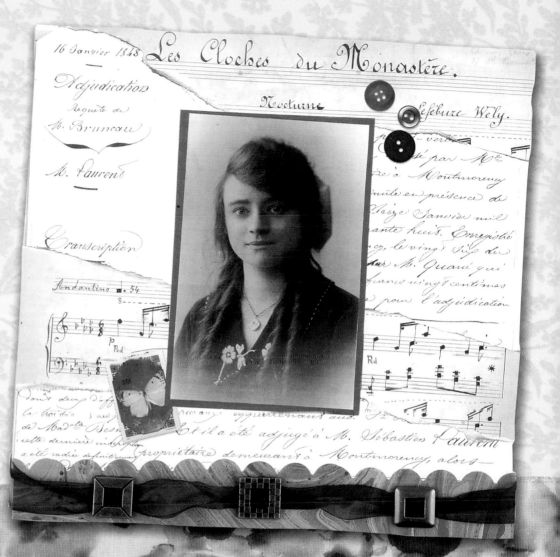

OPTIONAL: Depending on the type of three-dimensional elements you are adhering, you may or may not need to flatten your page again. If they are fragile, like bows or flowers, please don't! If they are bulkier items, such as several tags, pewter frames, or many buttons, you may want to place a 12" x 12" piece of plastic bubble wrap over your page, top with a few books, and let dry once more, overnight.

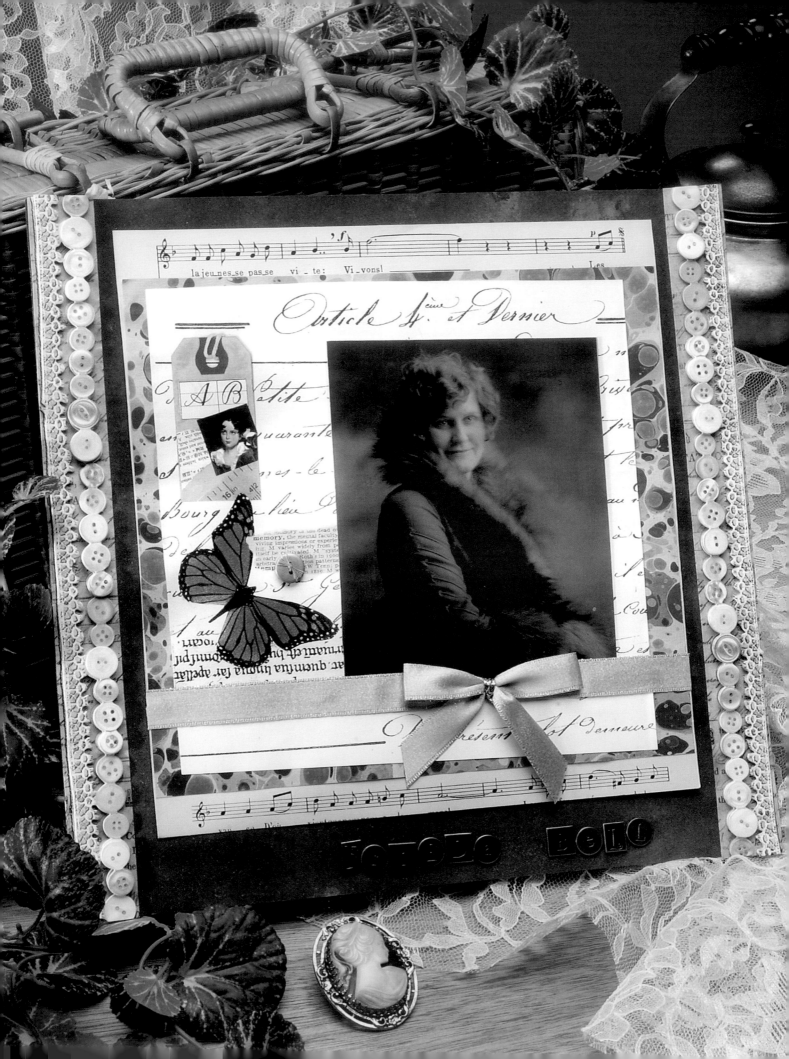

COLLAGE IS EASY IF YOU BREAK IT DOWN INTO SIMPLE STEPS:

 1 Select your photo(s)

 2 Choose your background

 3 Add other materials

 4 Play with the pieces

 5 Glue, flatten, dry

6 Add embellishments

Here's a good example:

FREIDA BELL

Jill Haglund

MATERIALS:

SHIPPING TAG: OFFICE SUPPLY (COFFEE-DYED)

GOLD ADHESIVE THREADED BUTTON: STICKO "BUTTON UPS"

BUTTONS AND LACE BORDER AND PEWTER CORNERS: K&COMPANY

PEWTER LETTERS: MAKING MEMORIES

BACKGROUND PAPERS: 7GYPSIES "TERRE"

ADHESIVES: YES! PASTE; ART ACCENTZ STICKY TAPE; USE GLUE DOTS INTERNATIONAL OR ULTIMATE GLUE FOR PEWTER PIECES

OTHER: DICTIONARY PAGES, LATIN TEXT, ART SQUARE AND BUTTERFLY FROM OLD ENCYCLOPEDIA, GOLD RIBBON, MARBLED AND SCRIPT PAPER, PENMANSHIP PAPER AND RULER ACCENT ON TAG

INSTRUCTIONS:

Select papers and additional elements. Start by first coffee-staining tag, then glue the ruler, penmanship piece, foreign text and small art square onto the tag; trim the edges if necessary. Collage butterfly, torn Latin text, dictionary definition and tag as shown. Finally, tape on photo. After page has dried and flattened, add the border to both sides, gold button next to butterfly and gold ribbon across the bottom of the photograph. Spell out name in mixed types of pewter letters.

[CREATIVE TIP]

Coffee-dyed materials (papers, tags, fabrics and lace) are staples for collage with a vintage theme. You'll see them used in page designs throughout this book. You can coffee-dye sheet music, newspapers, tags, lace trim, doilies and just about anything paper or fabric. It's most convenient to do ahead of time. Dedicate a morning or afternoon to coffee-dying, using various strengths of coffee to achieve a mix of lights and darks.

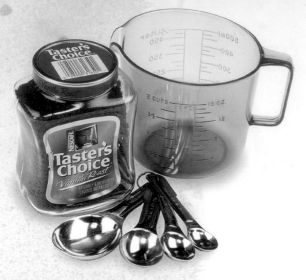

MATERIALS:

TRAY OR PAN LARGE ENOUGH TO HOLD YOUR PAPERS

PAPER, TAGS, FABRICS OR LACE TRIM

JAR OF TASTER'S CHOICE VANILLA ROAST INSTANT
COFFEE (5 TABLESPOONS)

WATER (2 CUPS)

STACKS OF NEWSPAPERS

OPTIONAL: ADD 1 TEASPOON
OF BRILLIANT GOLD PEARL EX

INSTRUCTIONS:

Prepare by laying out your newspapers in triple
thickness over a flat area. Boil 2 cups of water in a
sauce pan or in the microwave. Remove from heat and
carefully add 5 tablespoons of the recommended type
of coffee. (Some work better then others; this one
makes your papers smell delicious!) Stir until dissolved.
Add and melt two or three ice cubes to make the coffee
temperature comfortable to work with. Please do a
"finger-tip check" before you place your hands into the
tray, as everyone's temperature threshold is different.
The water should be warm, not hot. Just remember, the
ice cubes dilute the coffee color. Pour the warm coffee
into your tray. Add your paper and let it soak about 30
seconds to absorb the color. Pull out your paper and
place onto newspapers for drying. If desired, before the
page dries completely (while it's still glistening), finely
grind a few coffee granules between your fingers,
then sprinkle over your page to enhance the look of
antiquity. You can coffee-dye paper, tags, lace
trim, fabric and ephemera.

[CREATIVE TIP]
You may use walnut granules
instead of instant coffee.

WAKE UP AND SMELL THE COFFEE!
How to Make Coffee-Dyed Paper

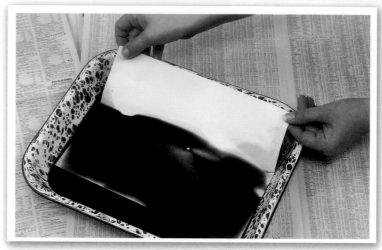

STEP 1
Add your paper and let it soak about 30 seconds to absorb the color.
Pull out your paper and place onto newspapers for drying.

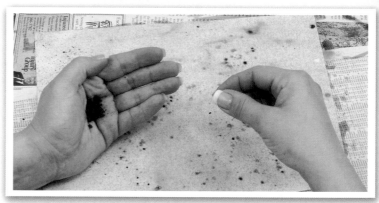

STEP 2
Before the page dries completely (while it's still glistening), finely
grind a few coffee granules between your fingers, then sprinkle over
your page to enhance the look of antiquity.

STEP 3
You can coffee-dye paper, tags, lace trim, fabric and ephemera. Place
a coffee cup into a liquid coffee or walnut ink mixture and set onto
your paper to create "coffee rings". Let dry before lifting coffee cup.

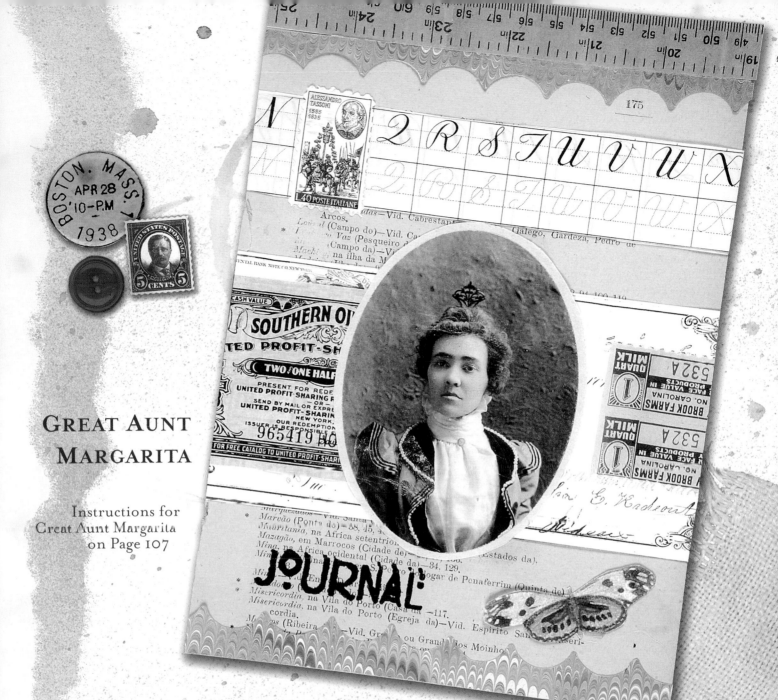

GREAT AUNT MARGARITA

Instructions for
Great Aunt Margarita
on Page 107

The vintage era is clearly portrayed on the Great Aunt Margarita layout. Notice the coffee-dyed book page; the ephemera helps tell her story. Since Aunt Margarita was a teacher, an old penmanship book page was used in the background. An ardent naturalist, she studied and loved nature. The butterfly, journal rubber stamp, floral postal stamp and documentation on ledger paper on the following page tell what little was known about her. Her husband was a dairy farmer, represented by the two milk ticket stubs.

This example will give you an idea of what to keep your eyes open for when you're collecting. Look for vintage items from the time period you are representing ... tell a story through the objects you find.

[CREATIVE TIP]
Try photo tinting for a hint of color that brings beauty and life to your old photographs! It is as easy as using a marker; the color of the photo pens create just a blush or tint.

Imagine a scrapbook full of elegant, nostalgic pages like these for your old, sepia-toned photographs. When you hold your family's heritage album you'll feel like you're holding a treasure.

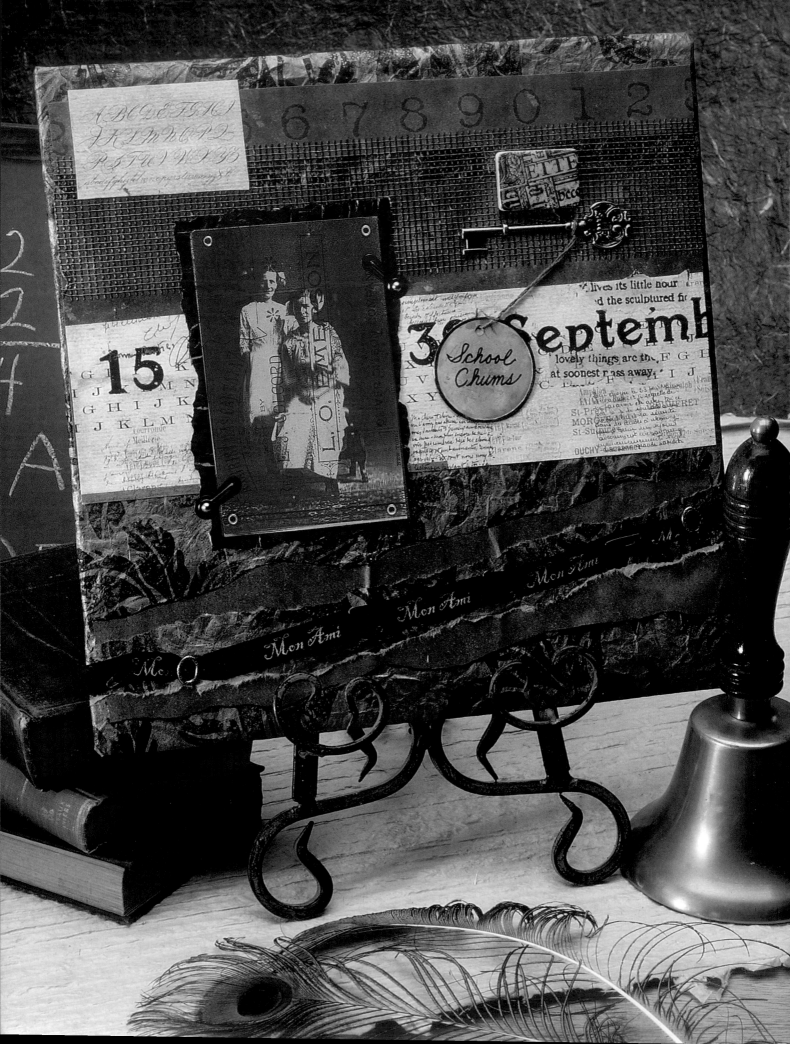

CHAPTER

Eyelets, snaps, brads and photo turns are a big part of collage. They add interest, texture and a true Old World feel when used to attach a photograph, tag, ephemera or transparency. Eyelets come in different sizes, usually 1/16", 1/8" and 3/16". Although each size eyelet has a corresponding setting tool, the largest setting tool will work for all three. Eyelets come in a variety of shapes and colors...copper, brass, black, silver, hunter green, yellow, ivory, burnt orange, burgundy, blue, lavender...and the list goes on. Snaps usually come in two sizes, a variety of colors and are set with a tool just like an eyelet. Brads are available in large or small sizes and nail head, star, square or heart shapes. Photo turns are brass, silver or black and come in two sizes and shapes. Use whatever strikes your fancy! Just flip through these pages to see effective use of eyelets, snaps, brads and photo turns.

SCHOOL CHUMS
Joey Long

MATERIALS:

PAPERS: 7GYPSIES "CALENDRE" AND "LESSON"

PHOTO TURNS: 7GYPSIES

CHARMS AND SAFETY PINS: MAKING MEMORIES

"MON AMI" RIBBON: THE CREATIVE BLOCK

RUBBER STAMP (ON TILE): STAMPERS ANONYMOUS

KEY: LI'L DAVIS DESIGNS

SIENNA INK: ANCIENT PAGE DYE INK

OTHER INKS: COLORBOX FLUID CHALK INKPADS

BRONZE MESH: MAGIC MESH

EYELETS: MAKING MEMORIES

ROUND TAG: OFFICE SUPPLY

ACRYLIC PAINTS: FOLKART BY PLAID

EMBOSSING HEAT GUN: MARVY UCHIDA

ADHESIVES: ART ACCENTZ STICKY TAPE; UHU GLUE STICK

OTHER: GAME TILE, HANDMADE PAPER FROM GROCERY BAG

INSTRUCTIONS:

Cover your scrapbook page with handmade paper (grocery bag paper painted with acrylic paints) for the background. Attach strips of 7gypsies decorative papers 1/2" apart. Layer a length of bronze mesh and scrap of "Lesson" paper. Layer photo transparency over scrap of found paper (artist's collection) and attach with eyelets. Layer torn strips of brown paper, decorated grocery bag, and ribbon. Attach two ribbon charms, then pin all together with safety pins. Tape to page; add key. Age game tile with sienna ink; set with an embossing heat gun. Do not pick up the tile, but while it is still hot, rub and melt crayon along edges until you get the desired effect. Stamp your chosen image on tile with dye ink and tape tile to page. Stain just around the tag edges with ink pads. Handwrite "school chums" on tag and glue to scrapbook page. Attach black photo with photo turns as shown.

EYELETS, SNAPS, BRADS & PHOTO TURNS

EYELETS

Check the size of your eyelet and choose the appropriate punch and eyelet setting tool.

STEP 1

Tape all layers and punch with hand punch.

STEP 2

Place eyelet in hole, then flip over the papers (or page) onto a firm surface.

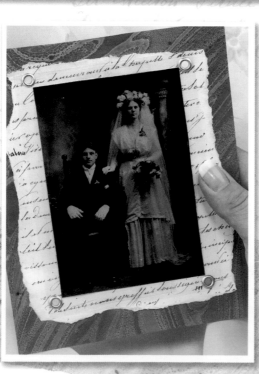

STEP 3

Insert the eyelet setting tool in the unfinished end of the eyelet. Hold the eyelet setting tool straight and tap the end of it with a hammer until the top curls over.

STEP 4

Hit straight down, not at an angle, so it curls over evenly. It takes a little practice!

FROLICKING AT JERSEY COAST

Jill Haglund

MATERIALS:

ALPHABET BUTTONS: JUNKITZ

"SUMMER" ZIPPER PULL: JUNKITZ

TAGS: OFFICE SUPPLY (COFFEE-DYED)

BLUE EYELETS: MAKING MEMORIES

VELLUM PAPER AND CARD STOCK: LOCAL CRAFT STORE

METALLIC PHOTO CORNERS: CANSON

BLUE INK: COLOR BOX "CAT'S EYE"

BROWN INK: STAZON

STIPPLE BRUSHES: TOY BOX RUBBER STAMPS

ALPHABET RUBBER STAMPS: GREEN PEPPER PRESS

ADHESIVES: SCOTCH VELLUM TAPE; THE ULTIMATE! GLUE OR YES! PASTE

OTHER: ANTIQUE BUTTONS, COFFEE-DYED NEWSPAPER, BUTTON THREAD, LARGE-EYED NEEDLE, RICKRACK, 12" X 12" HANDMADE COFFEE-DYED PAPER FOR BACKGROUND AND MARBLED PAPER

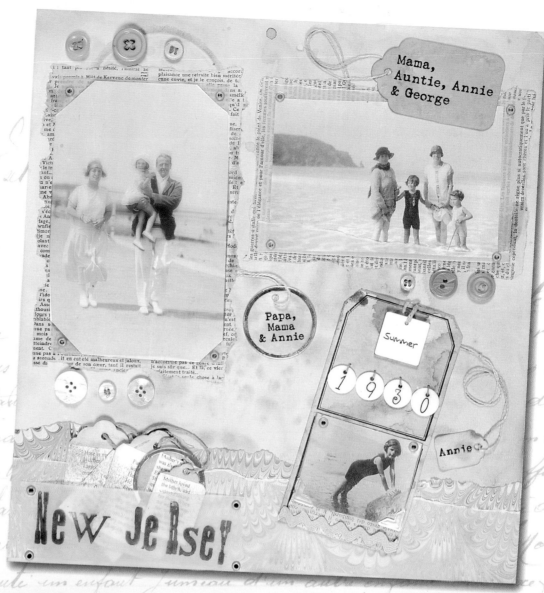

Red Admiral

INSTRUCTIONS:

Copy all your photographs onto transparencies and tape to white card stock. Next, cut vellum and place behind photographs. Make rectangular vintage mats by placing pieces of coffee-dyed newspaper behind the vellum and tearing around the edges to size. Carefully rub blue ink on the torn edges. Place the vellum onto the prepared newspaper mat and the transparency on top of the white card stock then the vellum. Punch four holes for each picture; place and set eyelets. Notice the photograph where the vellum was folded up around the edge prior to punching holes and adding eyelets. Glue all newspaper mats onto coffee paper as indicated. Glue tags (except "Summer"), tuck and move tag strings as shown.

For the "Summer" tag, glue the coffee-dyed newspaper on the bottom edge for a border and layer the newspaper with a short piece of rickrack. Adhere small photo with eyelets, photo corners and double-sided tape. Tie "Summer" to the top of the tag and sew buttons in place with button thread and a large-eyed needle.

Tear marbled paper and glue to bottom of page. Next, tear vellum strips and layer with vellum tape over marbled paper. Stamp "New Jersey" on a cut strip of blue vellum; dry with heat embossing tool. Place stamped strip of vellum across the page and punch holes through all layers. Add eyelets, flip page and set. Computer-generate journaling, cut out and glue onto small tags; stiple with inks and tuck into the vellum strip. Dry flat, then add antique buttons and "Summer" tag to page.

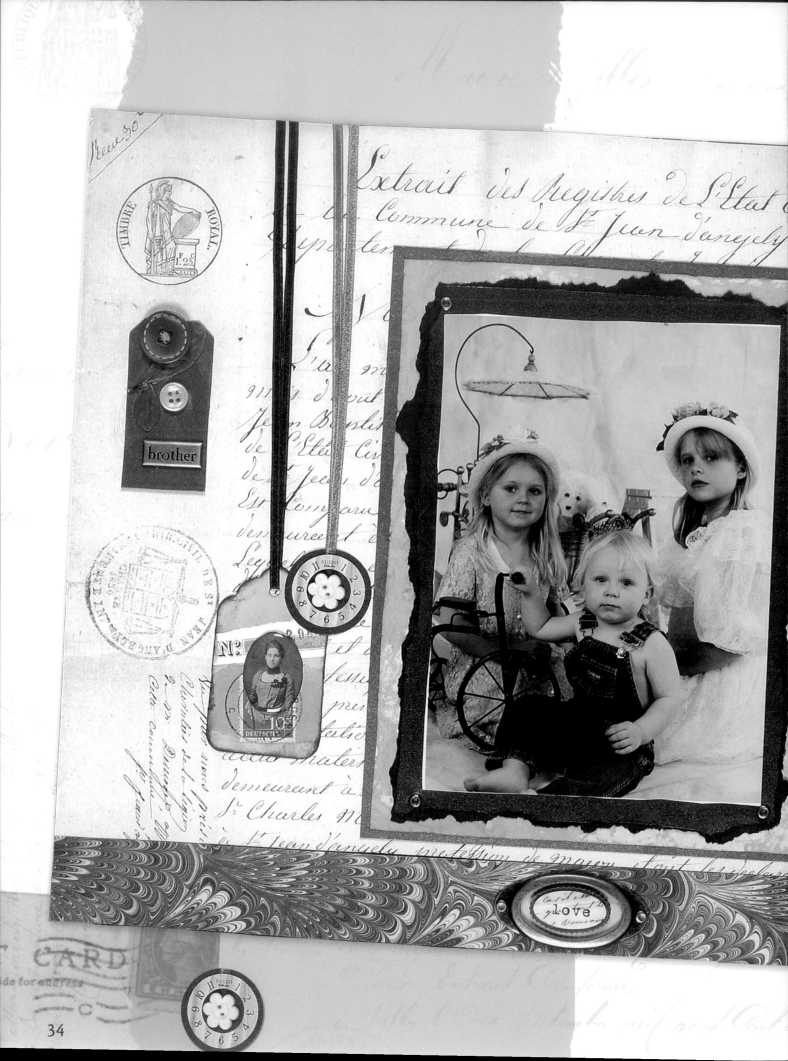

JESSIE, JACOB AND SARAH
Jill Haglund

MATERIALS:

COPPER TAGS AND THIN RIBBONS: THE CARD CONNECTION

PEWTER "BROTHER" PLATE: MAKING MEMORIES

BRONZE PAPER: MARCO'S "STARDREAM"

BROWN INK: COLORBOX "CAT'S EYE"

CLOCK: 7GYPSIES

CLEAR PAGE PEBBLE: MAKING MEMORIES

FLOWER BUTTON: LOCAL CRAFT STORE

TAG: OFFICE SUPPLY

BRASS OVAL LABLE HOLDER: MAKING MEMORIES

OVAL "LOVE": K&COMPANY

ADHESIVES: ART ACCENTZ STICKY TAPE; YES! PASTE; GLUE DOTS INTERNATIONAL

OTHER: TWO SMALL LEAVES, CANCELED POSTAGE, WRINKLED COFFEE-DYED PAPER, SMALL VINTAGE PHOTOGRAPH, TORN CANCELED CHECK, MARBLED AND FRENCH SCRIPT PAPERS

INSTRUCTIONS:

Paste French script paper for the background and a strip of marbled paper for the bottom border. Layer bronze paper, wrinkled coffee-dyed paper and torn bronze paper with tape. Punch holes in corners close to photo; place and set eyelets. Dry and flatten. Now you are ready to make all three tags.

1. Rectangular copper tag (on far left): Adhere leaves buttons and pewter "brother" as shown.

2. Coffee tag (in the middle): Glue canceled postage onto tag and place small photo under page pebble; trim if needed. Place a strip of torn canceled check across tag and wrap around the back. Rub the edges of the tag with brown ink. Glue pebble with photo on top; string with thin ribbon.

3. Round copper tag (to the right): Adhere antique clock face, add to circular tag and thread with copper ribbon.

4. Once page is dried, glue tags as shown. Be careful with ribbon; pull it tight and straight. Add button to clock face. Place bubble wrap over the page and gently top with heavy books. Dry overnight to set.

IDEAS FOR BRADS, EYELETS & SNAPS

Remember brads from your school days?
The brads everyone uses today on their scrapbooks are a similar version of the same, and come in a variety of colors, sizes and shapes. To use brads, punch a small hole with an Anywhere Punch and slip the ends of the brad through the hole; pry open the back of the brad with your fingers to hold it into place. Brads are an alternate way to attach a label, title, tag, photo transparency, matted photograph or just about anything. Sometimes brads are added just for effect.

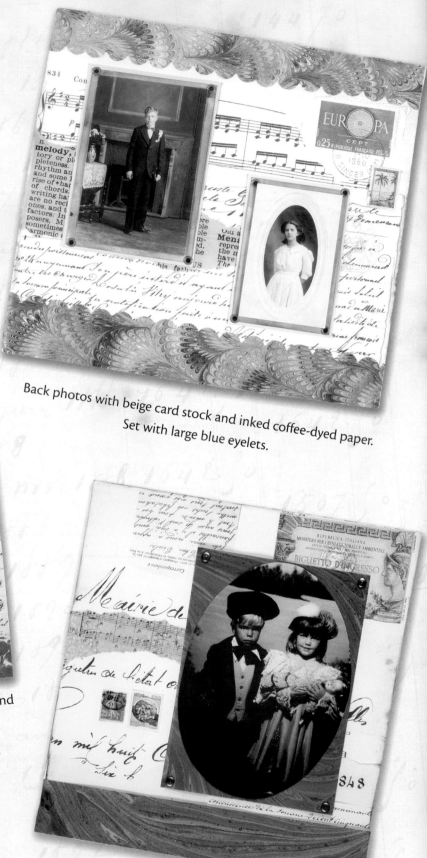

Back photos with beige card stock and inked coffee-dyed paper. Set with large blue eyelets.

Use inked, wrinkled coffee-dyed paper, red ridged paper and torn white mulberry paper as a mat.

Set off the page with eyelets by Creative Imaginations.

Simply add marbled paper and copper snaps.

imagine

36

See how much fun you can have with brads! Both functional and eye-catching, they come in different sizes and shapes…nails, stars, hearts, squares and more.

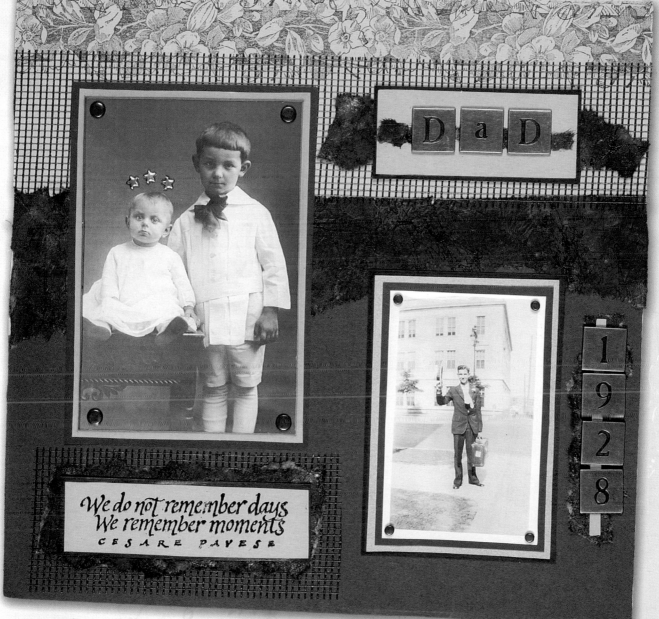

DAD 1928

Joey Long

MATERIALS:

PEWTER LETTERS: MAKING MEMORIES

SNAPS: MAKING MEMORIES

BRONZE MESH: MAGIC MESH

BLACK INK: STAZON

QUOTE RUBBER STAMP AND SMALL STAR BRADS: PSX

RUBBER STAMP:
FLOWER BORDER BY MAGENTA

CARD STOCK: LOCAL CRAFT STORE

ADHESIVES: ART ACCENTZ STICKY TAPE, YES! PASTE; GLUE DOTS INTERNATIONAL;

OTHER: HANDMADE PAPER

INSTRUCTIONS:

Tear a 12" x 12" piece of kraft paper and stamp flowers in black ink for a top border. Tear brown 12" x 12" paper for bottom of page. Paste handmade paper over brown and add mesh in all areas as shown. Stamp saying, tape to colored card stock and handmade paper, then to mesh. Cut rectangles of card stock, add handmade paper, and "DaD" in pewter letters, tape to mesh. Trim and mount photographs, set snaps, add star brads as shown and tape to page. Add a small strip of handmade paper and pewter numbers "1928".

37

PHOTO TURNS

Photo turns can make a photograph look extra special! These small "flippers" fastened with brads not only hold your photo in place, but create a fun, whimsical frame. They are available in brass, silver and black as well as in two sizes and shapes. Here are some tips on how to use them.

[C R E A T I V E T I P]
Mix and match! Try placing photo turns at the top or at different corners on a diagonal, or use two large turns at the top of the photo and two small ones at the bottom.

STEP 1

Decide exactly where on your page you want the photograph. Use a pencil to mark small holes for the brads that will affix the photo turns to the scrapbook page. The marks should be fairly close to the edges of the photograph.

STEP 2

Place the page on your mat and punch the marked holes.

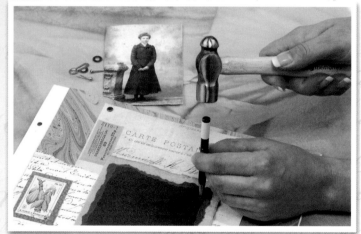

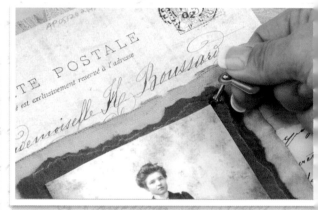

STEP 3

Place the photograph and position one photo turn at a time. Slip in a long brad to go through several layers, or use a smaller brad for a thin layer. The turns should rest on the photograph tightly enough to hold it down, yet loosely enough to enable you to remove the photo if necessary.

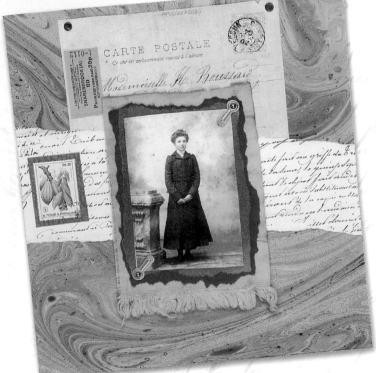

STEP 4

To hold the photo turn in place, turn over your page and place a small washer over the back of each brad before you bend back the prongs.

PHILLIP

Jill Haglund

MATERIALS:

COSETTE PAPER AND LONDON TIMES TRANSPARENCY: 7GYPSIES

PHOTO TURNS, HEART SPIRALE CLIP, GOLD FRAME, DRAWING IN FRAME, TWILL "BABY" BORDER: 7GYPSIES

GREEN MESH: MAGIC MESH

CARD STOCK: LOCAL CRAFT STORE

KEY AND KEY HOLE: LI'L DAVIS DESIGNS

CLIPIOLA: STAMPINGTON & COMPANY

LABEL HOLDER: LI'L DAVIS DESIGNS

FIBERS: RIVER COLORS STUDIO

ADHESIVES: ART ACCENTZ STICKY TAPE; 101 HEAVY ARTIST'S CEMENT; THE ULTIMATE! GLUE

OTHER: COFFEE-DYED PAPER, TEXTURED PAPER USED FOR SHIPPING AND MARBLED PAPER

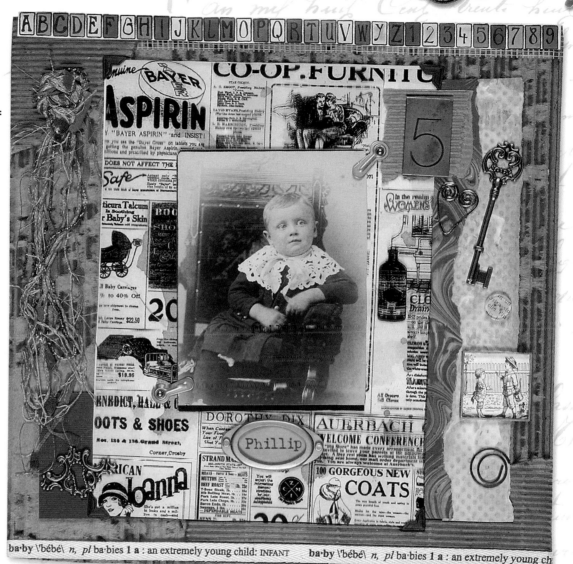

[CREATIVE TIP]

The Anywhere Punch is an amazing tool! It can penetrate many layers at once and it can be used in the middle of a 12" x 12" page, or just about anywhere!

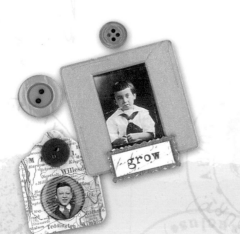

INSTRUCTIONS:

Use a piece of corrugated cardboard as the background, peeling off top layer to reveal the texture. Place the marbled papers and card stock as shown; layer on textured paper. Rub artist's cement over all the textured paper to enhance its dimension. Glue fibers as shown. Cover a light colored coffee-dyed paper with a printed transparency. Place photo on transparency with tape and photo corners. Add green mesh and paper as a top border. Glue label holder under portrait. Add small drawing under frame and glue onto side. Adhere clock face, heart spirale clip, clipiola, key hole, key and "5" with small amount of glue. Adhere twill "baby" border to bottom of page.

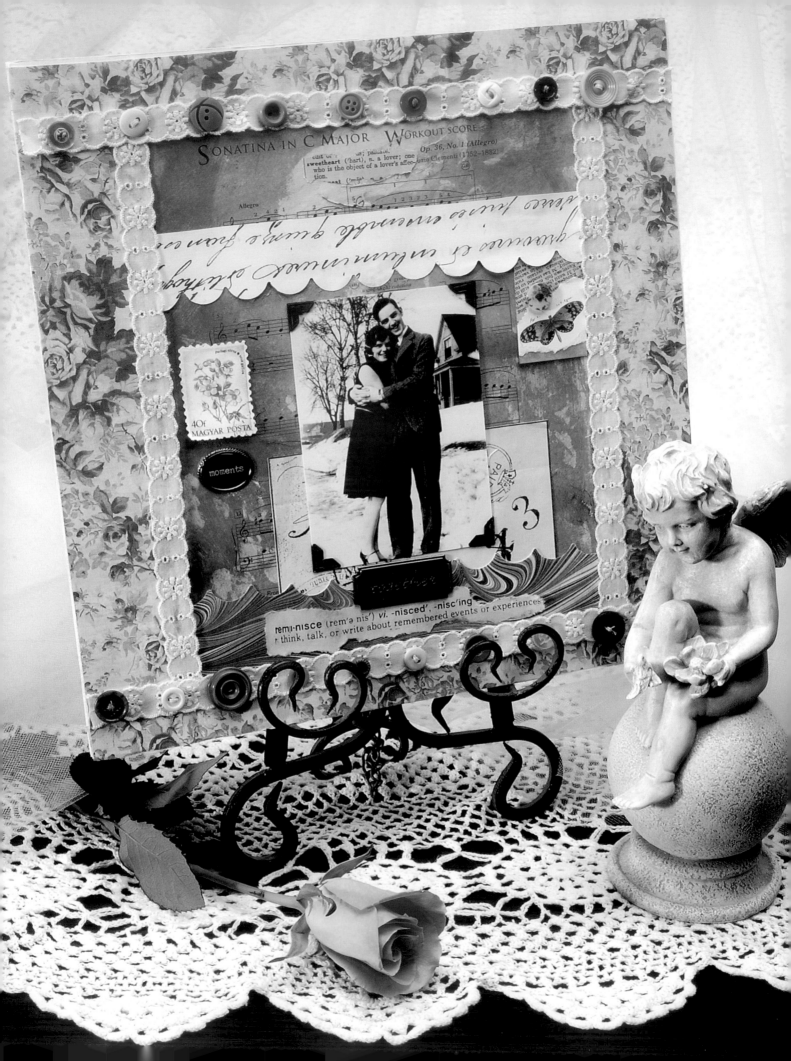

Capture the romance of the Victorian era with unique accents … nothing says "vintage" more than antique buttons, ribbons and lace. Feminine and pretty, they conjure up lovely images of warmth, elegance and special days gone by. You'll find buttons and ribbons in all colors; lace is best in shades of ivory, though most colors can be coffee-dyed to achieve an aged effect. Local craft and sewing stores offer an infinite variety. Shop for them when traveling, especially in foreign countries; these items not only enhance your page with eclectic beauty, but they also make great souvenirs. Browse through your heirlooms … preserve great grandmother's lace hankie for posterity. So, start collecting! Buy, borrow, barter and beg. With a treasure trove of antique buttons, ribbons and lace, you'll be ready to dress your pages in vintage style.

MOMENTS TOGETHER

Jill Haglund

MATERIALS:

MARBLED PAPER: PAPER PASSIONS

FLORAL PATTERN PAPER: ANNA GRIFFIN

PHOTO CORNERS: CANSON

BLACK "MOMENTS" BUBBLE PHRASE, OVAL DISC, PEWTER "TOGETHER" PLATE: LI'L DAVIS DESIGNS

FLORAL ADHESIVE BUTTON: STICKO "BUTTON UPS"

PRUSSIAN BLUE AND ROSE INK: COLORBOX FLUID CHALK INKPAD

STYLUS: COLORBOX

ADHESIVES: ART ACCENTZ STICKY TAPE; THE ULTIMATE! GLUE; GLUE DOTS INTERNATIONAL

OTHER: DICTIONARY PAGES, SHEET MUSIC AND SCRIPT PAPER

INSTRUCTIONS:

For sheet music background, randomly rub inks onto paper with stylus. Cut a two-inch strip of marbled and script papers; cut with scallop scissors for borders. Adhere ephemera piece to the lower half of background. Put photo corners on photo and glue as shown. Add the script and marbled border as indicated. Next, glue coffee-dyed newspaper to the top part of a coffee-dyed tag; add butterfly and button as shown and tuck under border. Copy dictionary definitions onto coffee-dyed paper, and tear out; glue "sweetheart" above top script border and "reminisce" on the bottom marbled border. Add postage stamp and adhere metal "moments." Press bubble phrase into oval disc and glue to music sheet. Tape metal plate, "together" below the photograph. Tape 12" x 12" floral pattern to your scrapbook page; place smaller layout in center and surround with lace. Adhere buttons with glue dots as shown.

BUTTONS, RIBBON & LACE

GRANDMOTHER, MOTHER AND PATSY
Joey Long

MATERIALS:

TAPE MEASURE, RATION CARDS, HOOK AND EYE: PAPERBAG STUDIOS

WATERCOLORS: IRIDORI

NUMBER RUBBER STAMP: TREASURE CAY

HAND-DYED SILK RIBBON: JKM RIBBON AND TRIMS

PHOTO OF WOMAN WITH RIBBON: VINTAGE CHARMINGS

ADHESIVE: JUDI KINS DIAMOND GLAZE; YES! PASTE; UHU GLUE STICK

OTHER: COFFEE-DYED PAPER, BUTTON, CLOCK AND MARBLED SCRIPT PAPER

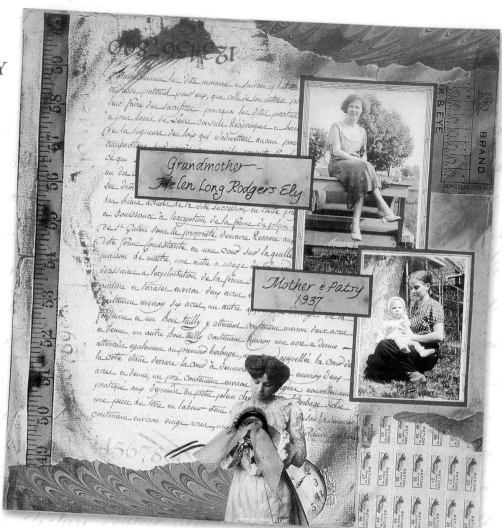

Grandmother —
Helen Long Rodgers Ely

Mother & Patsy
1937

INSTRUCTIONS:

Collage marble and script papers as backgrounds. Use makeup sponge to rub antique lime and burnt sienna watercolors across the paper. Add photos matted onto black card stock and other pieces; paste cutouts of woman clock, ration cards and hook and eye as shown. Thread ribbon through button and glue onto woman's hand with diamond glaze.

REMEMBER
Jill Haglund

MATERIALS:

MARBLED PAPER: PAPER PASSIONS

ALPHABET AND "WHAT, WHERE, WHEN AND WHO" RUBBER STAMPS: PAPERBAG STUDIOS

SQUARE NUMBER STAMPS: STAMPERS ANONYMOUS

"REMEMBER" RUBBER STAMP: INKADINKADO

SKELETON LEAF: BLACK INK

TAGS (COFFEE-DYED): OFFICE SUPPLY

ADHESIVE: ART ACCENTZ STICKY TAPE; UHU STICKY TAPE; GLUE DOTS INTERNATIONAL

OTHER: COFFEE-DYED PAPER AND SCRIPT PAPER

RETAIN THIS CHECK

Remember...

040

1 9 1 3

What?

Where?

When?

Why?

Frieda Bell Hill (my Grandma) is on the front of the horse, her sister, Emfrieda, on the back. Emfreida became ill and died, at 5 years of age, shortly after this photo was taken.

INSTRUCTIONS:

Stamp alphabet on coffee-dyed paper and layer script, marbled paper and alphabet images as shown. Tape photo on top of layers. Add ribbon, postage and leaf as shown. Stamp numbers on coffee-dyed paper and cut out; glue to bottom of tag. Cut a small piece of vellum, rub with ink pads, glue to tag and stamp "Remember." Stamp words, cut out and glue to tags. Glue tags to bottom of page; arrange string ties. Computer-generate information relating to the photo; cut out and glue to tag. Dry and flatten the page, then add buttons.

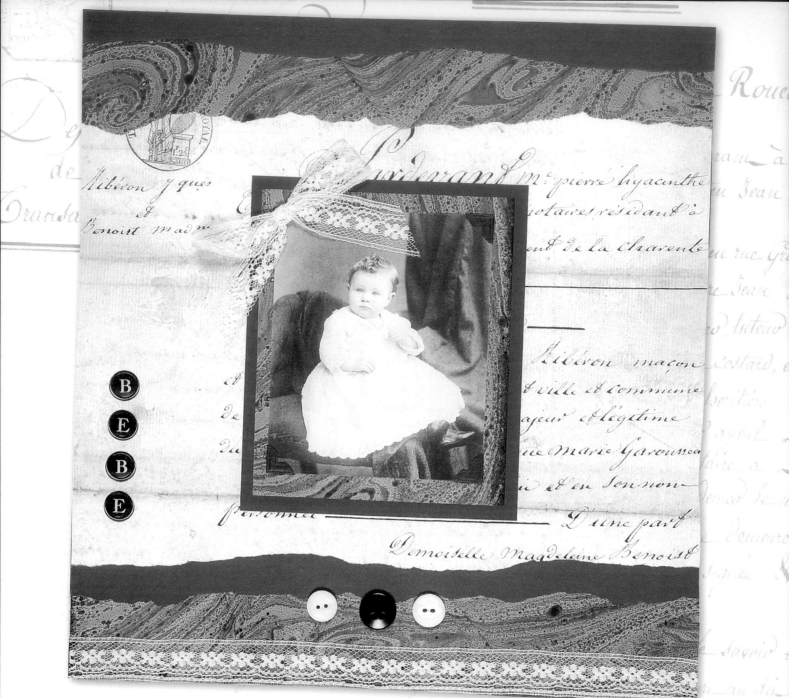

BEBE

Roben-Marie Smith

MATERIALS

MARBLED PAPER: ANGY'S DREAM

BLACK PHOTO CORNERS: CANSON

LETTER STICKERS: NOSTALGIQUES BY REBECCA SOWER

ADHESIVES: UHU GLUE STICK;
GLUE DOTS INTERNATIONAL; YES! PASTE

OTHER: LACE, BUTTONS AND SCRIPT PAPER

INSTRUCTIONS:

Tear old script and marbled papers and paste to page. Layer photo to script and marbled papers with photo corners; glue to page. Tie lace into a bow and glue to page. Add lace and buttons to bottom of page. Place letter stickers to side of photo.

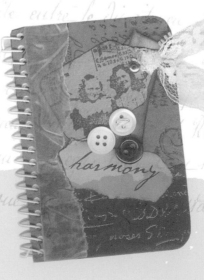

WENDY

Roben-Marie Smith

MATERIALS:

Pattern Paper: Anna Griffin

Brads, Metal Frame, Card Stock and Metal Letters: Making Memories

Flowers: The Card Connection

Ridged Card Stock: Local Craft Store

Silver Washers and Cheesecloth: Local Hardware Store

Adhesives: The Ultimate! Glue; UHU Glue Stick

Other: ribbon and script paper

INSTRUCTIONS:

Photocopy picture at 75%, cut out portion of girl's hands and glue under frame. Tear and layer script paper and pattern paper as shown. Cut and arrange cheesecloth around photo and adhere. Cut a piece of ridged paper and add metal letters with brads and position and glue to page. Glue frame in place. Using a hole punch, add holes to each corner of the page. Add a silver washer and thread ribbon through each hole and tie. Glue paper flowers to the top corner.

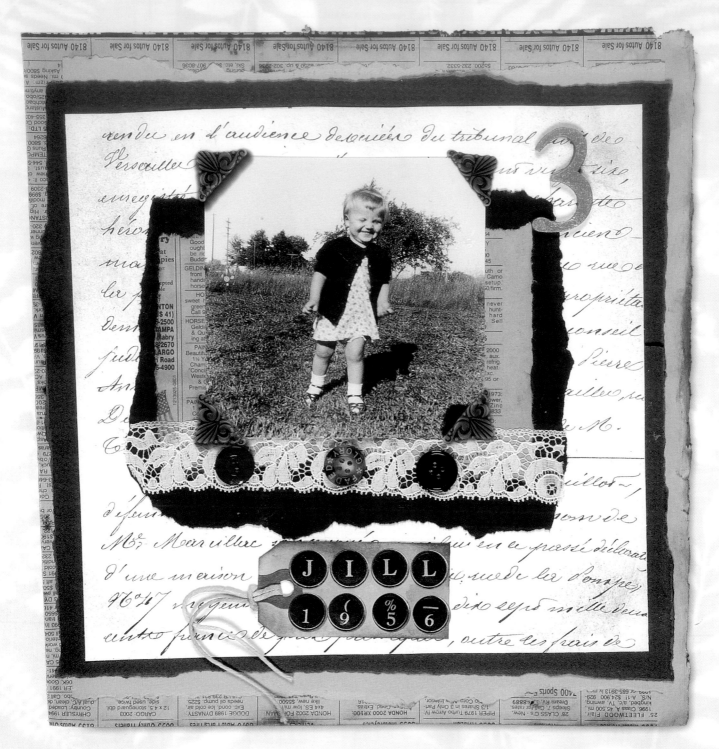

THREE YEARS OLD

Jill Haglund

MATERIALS

TYPEWRITER KEYS: NOSTALGIQUES BY REBECCA SOWER

PEWTER PHOTO CORNERS: K & COMPANY

INK: COLORBOX FLUID INKPAD

HEMP, BLACK AND ROYAL BLUE PAPERS: CANSON

ADHESIVES: UHU GLUE STICK; THE ULTIMATE! GLUE; YES! PASTE

OTHER: SCRIPT PAPER

INSTRUCTIONS:

Cut or tear, layer and glue background papers as shown. Tear black square and newspaper piece and glue lace on bottom. Glue this mat to center of page and adhere photograph. Using the direct-to-paper technique, lightly rub a few colors of ink onto the tag with stylus. Add letter and number stickers to the tag and glue to page. Using a stipple brush and inkpad, lightly stipple the page in various spots for color. Dry and flatten, then add the wooden "3" painted gold.

Lucy
Roben-Marie Smith

MATERIALS:

Marbled Papers: Angy's Dreams

Pattern Paper: Anna Griffin

Definition and Eyelets: Making Memories

Black Ridged Card Stock: Local Craft Store

Adhesives: UHU Glue Stick; Glue Dots International

Other: buttons, fabric, ribbon, lace and script paper

INSTRUCTIONS:

Tear and layer ridged card stock, pattern, marbled and script papers to page. Add a piece of fabric at the bottom corner. Computer-generate name and date. Photocopy definition to tan paper and cut out. Layer all to page. Glue old lace and photo to page. Add old beads with glue dots. Set three eyelets into page and tie ribbon through each.

Lucy

1916

CHERISH 1. to hold dear 2. to treasure, adore, value and love 3. to keep deeply in mind

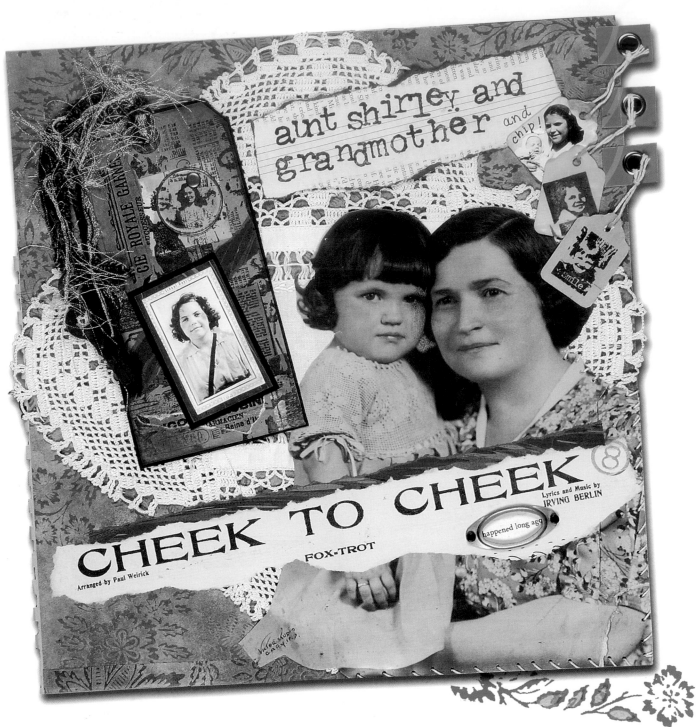

CHEEK TO CHEEK

Joey Long

MATERIALS:

PATTERN PAPER: SONNETS

GOLD PAPER: CENTURA

BLACK PAPER: CANSON

INKS IN VARIOUS COLORS: COLORBOX FLUID CHALK INKPADS

BLACK INKPAD: STAZON

"SISTERS" AND "THE PHARMACIST" RUBBER STAMPS: STAMPINGTON & COMPANY

ALPHABET, CHILDREN'S FACES, AND "8": PAPERBAG STUDIOS

KRAFT TAG AND BLACK BRADS: AMERICAN TAG

OVAL LABEL HOLDER: MAKING MEMORIES

ADHESIVES: ART ACCENTZ STICKY TAPE; UHU GLUE STICK; YES! PASTE

OTHER: TAB INDEXES FROM LI'L DAVIS DESIGNS PACKAGING, OLD DOILY AND SHEET MUSIC, CROCHET THREAD AND NEEDLE, AND SCRIPT PAPER

"*Tag, you're IT!*" *Tags really are "it" in collage, especially once they have been coffee-dyed.* A tag can make your entire collage come alive! No wonder it seems every other scrapbook layout includes at least *one* of them. They come in all shapes and sizes and are available at your office supply and local craft stores. New styles appear on the market almost daily in every color and texture you can imagine.

Tags add aesthetic appeal and, if used as a venue for documentation, provide bits of information about the "who, what, where or when" your page represents. You can color tags with coffee-dye or ink; you can stamp them, layer papers and photos on them and add vellum, fabric, ribbons, lace or buttons. They are like miniature blank canvases, just waiting for you to turn them into precious works of art. Tags are part of the artistic process, because they can provide balance. If you need weight or color on one side or corner of a page, simply place an embellished tag there and magic happens.

You can momentarily lose yourself in a well-designed collage. You'll feel compelled to study and appreciate the mélange of materials layered in a way that is both intriguing and uncluttered. The layered materials, tags among them, are what lend personality, dimension and depth.

Explore ways to play with tags. Although there are only a few ideas in this chapter, you'll find plenty more throughout the book.

INSTRUCTIONS:

Paste pattern paper to page. Sew on doily with crochet thread. Adhere enlarged, cut out photo as shown. Stitch the lower and right edges of the scrapbook page. Stamp sisters on large tag in various inks. Rub inks to color four squares of paper with various colors as shown, stamp sisters on each one and The Pharmacist on the gold paper and collage this all on the tag. Trim and glue to black paper, trim again leaving a slight edge. Mount and adhere school photo and attach circular tag with a brad as shown. Add fibers to tag, then tie an old skate key to fibers. Tape tag to page. Tear old music title (Cheek to Cheek), and layer onto marbled paper. Computer generate, "happened long ago" phrase on white paper, cut to fit under label holder. Adhere all to page. Stamp the "8" in blue ink. Cut three of the Li'l Davis Designs eyelet tab indexes from their packages into square shapes. Sandwich page in between tabs of eyelets as shown, letting part hang over the edge, secure with tape. Color tags and glue cut out small photo to one; stamp the others with children's faces and tie all to eyelets. Tear out a page from an old blank music pad, use alphabet stamps to journal. Glue to the page with a glue stick

TAG, YOUR IT!

Tags can be plain and simple, or complex and sophisticated. At a minimum, they add interest and color, but they can also tell a story about the person, event, or time period your page represents. Here's an example. This page is simple, yet elegantly vintage!

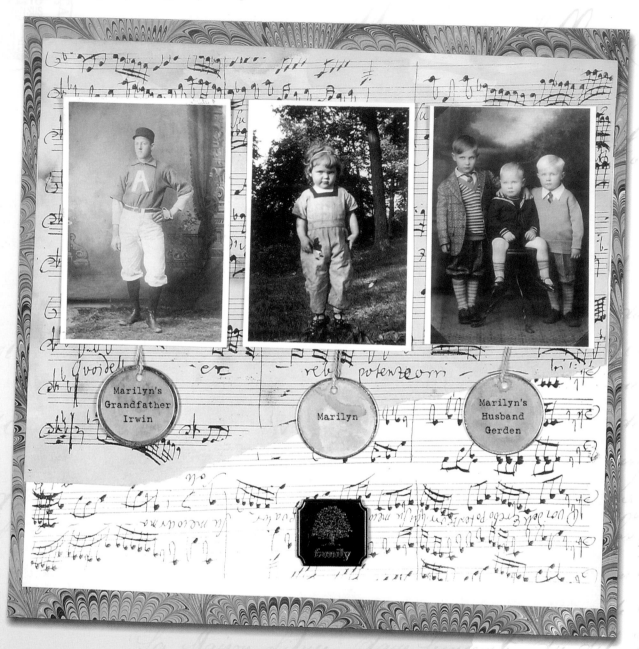

THROUGH THE YEARS
Jill Haglund

MATERIALS:

TAGS: OFFICE SUPPLY (COFFEE-DYED)

PEWTER "FAMILY" PLATE: LI'L DAVIS

ADHESIVES: UHU GLUE STICK;
YES! PASTE; ART ACCENTZ STICKY TAPE

OTHER: COFFEE-DYED PAPER, TAGS,
MARBLED AND SHEET MUSIC PAPERS

INSTRUCTIONS:

Coffee-dye sheet music; tear and layer onto page of white sheet music. Label tags and tape them by their strings to the backs of each photo; place photographs across the middle of the page. Glue entire page to marbled paper. Dry flat and add metal "family" plate as shown.

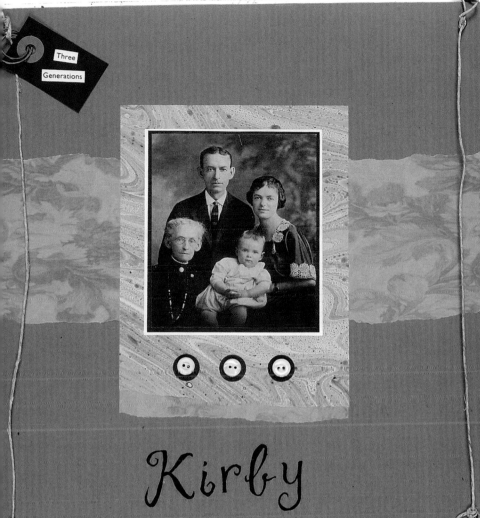

THREE GENERATIONS

Roben-Marie Smith

MATERIALS:

EYELETS, BLACK AND TAN CARD STOCK: MAKING MEMORIES

BLACK CLIPIOLA: STAMPINGTON & COMPANY

LETTER STICKERS: WORDSWORTH

TWO SIZES OF SMALL CIRCLE PUNCHES: MARVEY UCHIDA

TWINE: LOCAL CRAFT STORE

ADHESIVES: UHU GLUE STICK; GLUE DOTS INTERNATIONAL

OTHER: BUTTONS, TEAL PATTERN PAPER AND MARBLED PAPERS

INSTRUCTIONS:

Glue tan card stock to black card stock. Layer marbled and pattern papers to page. Glue photo to center as shown. Punch three black circles out of card stock and glue to page below photo. Glue buttons to circles with glue dots. Set eyelets in each corner and tie a piece of twine on each side as shown. Cut a small piece of card stock to make a tag. Punch a circle from tan card stock and glue to the top of tag. Punch through the circle with a smaller punch. Glue computer-generated text to tag. Pull black clip through hole and add to twine. Place word stickers under the photo.

INSTRUCTIONS:

Glue script, penmanship strip and ruler to page and cover with a large piece of sewing pattern paper; trim edges. Dry-brush taupe acrylic paint over the page. Tear and glue handmade paper to the bottom of the page. Tear and stamp names onto two pieces of handmade paper. For the five tags, sponge with dye inks, rubber stamp, embellish and glue to bottom of page. Prepare and layer photos and glue to page. Attach three eyelets to top right corner, glue on buttons. Place materials in gluchóns on top or bottom.

UNCLE SAM TAYLOR
Roben-Marie Smith

MATERIALS:

BRADS AND EYELETS: MAKING MEMORIES

RUBBER STAMPS: PSX, PAPERBAG STUDIOS

CLIPIOLA: STAMPINGTON & COMPANY

PHOTO CORNERS: CANSON

TAGS: OFFICE SUPPLY

INKS: ADIRONDACK; STAZON

TAUPE ACRYLIC PAINT: DECOART

BLACK MASKING TAPE: LOCAL CRAFT STORE

ADHESIVES: THE ULTIMATE! GLUE; YES! PASTE

PHOTOGRAPH: PAPERBAG STUDIOS

OTHER: SEWING PATTERNS, DICTIONARY PAGES, HANDMADE PAPER, SCRIPT PAPER, PENMANSHIP STRIP AND RULER

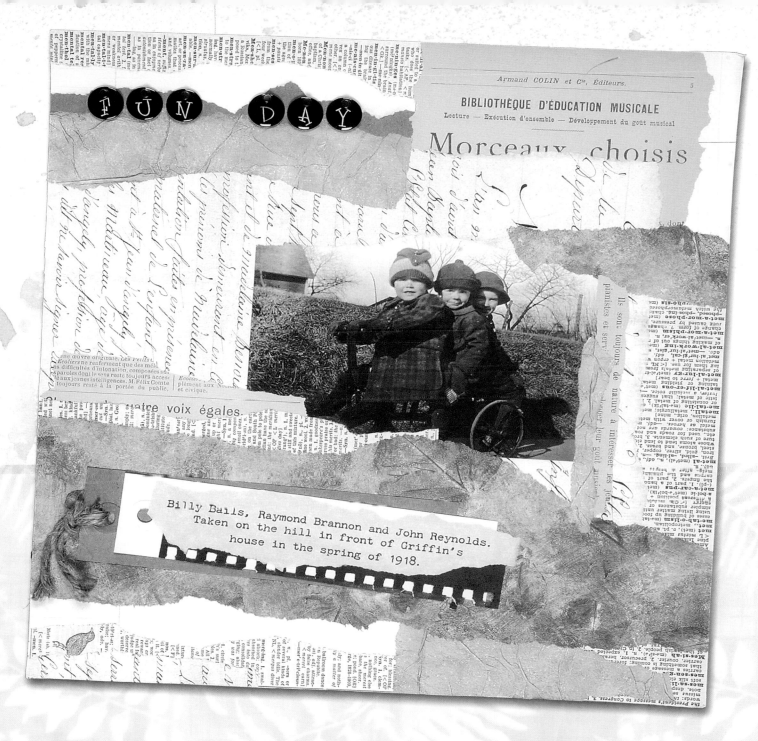

Billy Balls, Raymond Brannon and John Reynolds. Taken on the hill in front of Griffin's house in the spring of 1918.

FUN DAY

Roben-Marie Smith

MATERIALS:

PATTERN PAPER: AW CUTE AND SCRAP EASE

BUTTON LETTERS: JUNKITZ

TAGS: OFFICE SUPPLY

BRADS: MAKING MEMORIES

TWINE: LOCAL CRAFT STORE

ADHESIVES: THE ULTIMATE! GLUE; YES! PASTE

OTHER: DICTIONARY PAGES, BLACK NOTEBOOK PAPER, SCRIPT AND NOTEBOOK PAPER

INSTRUCTIONS:

Collage an assortment of papers. Adding the photo within the layers. Add button letters to page with eyelets. Cut tags to make them thinner and add twine to one. Glue tags, computer-generated text and torn black notebook paper to page.

generations

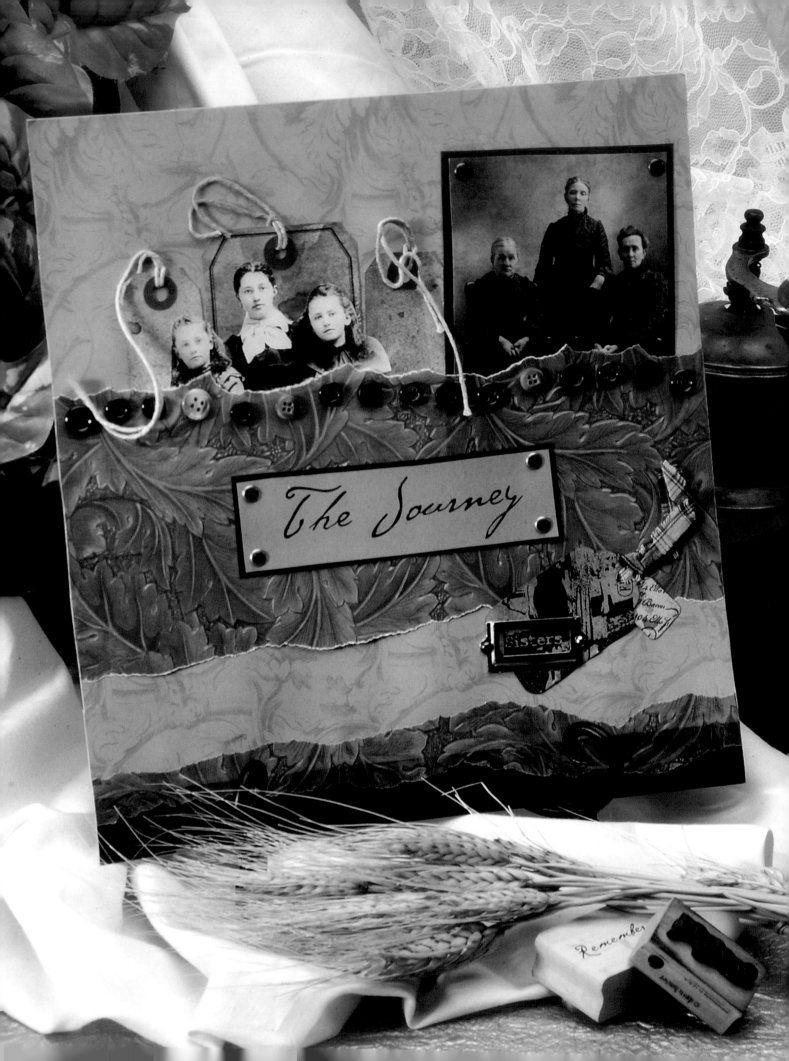

The Journey

Sisters

THE JOURNEY
Joey Long

MATERIALS:

Embossed Leaf Vellum Paper: K&Company

Pattern Paper: Anna Griffin

Black Paper: Canson

Snaps and Gold Label Frame: Making Memories

"Sisters" Rubber Stamp: Stampington & Company

Tag Template: Mini-Additions by C-Thru Ruler Company

Small Tags: Office Supply (coffee-dyed)

Adhesives: Art Accentz Sticky Tape; UHU Glue Stick; Yes! Paste; The Ultimate! Glue

Other: kraft paper, buttons

INSTRUCTIONS:

Paste black strip of paper and pattern paper to the bottom of the page. Tear edges of embossed vellum about 5" wide and layer across the middle of the page, gluing only the left and right edges. Cut out one photo and attach to three side-by-side coffee-dyed tags, tuck into vellum strip. Layer second photo to black paper with snaps, tuck into velum and tape securely, Glue buttons along the top torn edge of the vellum. Computer-generate "The Journey" onto kraft-colored paper and mount it to black paper, trim as shown. Punch holes using a hand punch; set brads and glue piece to page. Using template to trace tag onto kraft paper and cut out. Stamp "Sisters" on tag; add ribbon scrap.* Glue to page and tuck smaller stamped tag underneath as shown. Attach the label frame over the word "Sisters".

*Cut ribbon scrap from a larger piece, soak in water to remove sizing, then pull the threads from each end to age.

REMEMBER LOVE

By Roben-Marie Smith

MATERIALS:

GAME CARD PIECE, OLD POSTCARD EPHEMERA AND POSTCARD:
PAPERBAG STUDIOS

EYELETS, DEFINITIONS: MAKING MEMORIES

NAMEPLATE: ANIMA DESIGNS
BLACK PHOTO CORNERS: CANSON

TRANSPARENCY FILM: OFFICE SUPPLY

ADHESIVES: ART ACCENTZ STICKY TAPE; THE ULTIMATE! GLUE;
UHU GLUE STICK

OTHER: SPECIALTY RIBBON, BUTTONS, FRENCH TEXT, MARBLED,
MUSIC, SCRIPT AND FRENCH PRINTED PAPERS

CHAPTER 7

Transparencies are a jazzy new way to display your photographs. Ethereal, elegant and *easy*, using them can become addictive…especially once you see the results! Just copy your photograph onto a sheet of transparency film, add a background and *voila!* You will have instantly given your scrapbook page an extra touch of class. Not every photo is suited for transparency, however. The key element is the amount of light space in the photograph; it should have enough for the background to show through.

Backgrounds

When you choose a background, such as text or script, place the transparency over it and move it around. Remember, you want to be able to see the photograph. In general, try to avoid filling all the light space with busy text or design, you just want a little "something" to peek through. You can add colored vellum under your transparency and on top of your background; the three layers create a special effect. Try using a copy of colored, addressed envelopes with postage attached, or a handwritten letter for backgrounds. You don't have to place a background under the entire transparency. In fact, you don't have to use a background at all. Study our samples for design ideas — and experiment with your own.

Adhering Transparencies

Regular glue, paste or glue sticks are not recommended to adhere a transparency to your page; these adhesives may cloud the transparency surface. Eyelets, snaps or brads are a better choice. They not only add interest, but they are also neat and clean, and keep the surface crisp and clear. Another wonderful way to attach transparencies is by using the Xyron machine, even if you *are* using eyelets, snaps or brads. Just run the transparency through the Xyron, peel it off and stick it to your page. Art Accentz Sticky Tape is also a very functional and clean adhesive for transparencies. Handle your transparency with care; hold it by the edges to avoid fingerprints. If you want to glue dimensional objects like buttons onto the corners, Glue Dots International work best.

Extremely Important: Types of Transparency Film Sheets

There are two types of transparency film; one is for use with inkjet printers, the other, for laser copiers. They are NOT interchangeable! Use inkjet transparency film for inkjet printers, and laser or copier film for laser copiers, including and especially commercial machines. Laser copiers operate at significantly higher temperatures. If you use a sheet of transparency film designed for an inkjet on a laser machine, the film will melt and ruin the copier! Always ask for assistance from the management before attempting to use transparencies in a commercial copier.

INSTRUCTIONS:

Photocopy an image onto a sheet of transparency film. Tape to script paper and set with eyelets. Layer paper ephemera, marbled paper and text paper to page in a three-row grid format. Tape photo, transparency and postcard to page. Glue specialty ribbon, buttons and nameplate as shown.

THE KEY TO TRANSPARENCIES

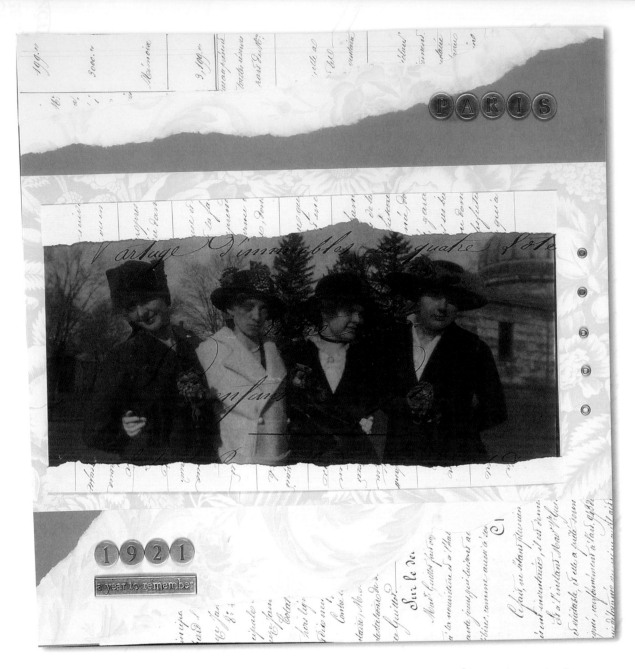

PARIS 1921

By Roben-Marie Smith

[CREATIVE TIP]
You can use Sticky Tape or run your transparency through the Xyron Machine to easily adhere it to paper.

MATERIALS:

PATTERN PAPER: ANNA GRIFFIN

CARD STOCK, EYELETS, WORD AND PEWTER LETTERS: MAKING MEMORIES

TRANSPARENCY FILM: OFFICE SUPPLY

ADHESIVES: ART ACCENTZ STICKY TAPE OR XYRON MACHINE; THE ULTIMATE! GLUE

OTHER: OLD SCRIPT PAPER

INSTRUCTIONS:

Copy photograph onto a sheet of transparency film and cut to fit script paper. Layer pattern paper, old script and card stock to page. Tape transparency to page. Glue metal letters to page and set eyelet plate and eyelets.

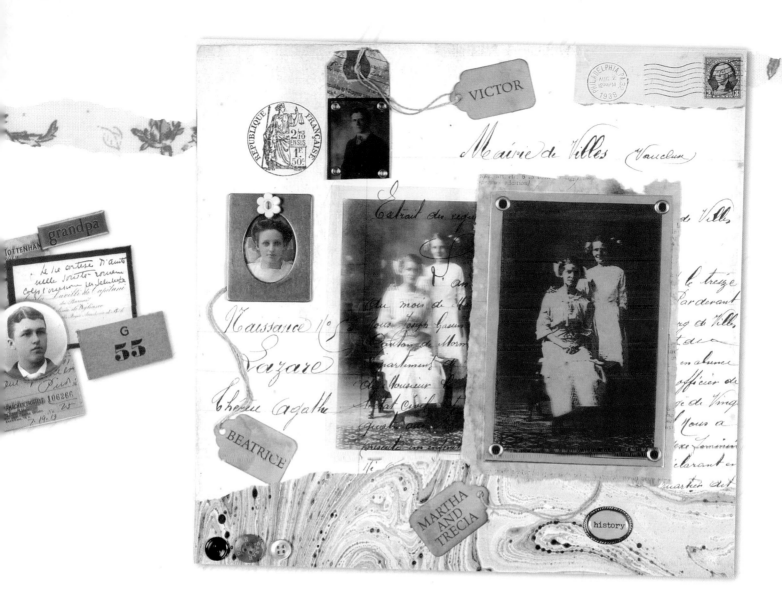

FAMILY HISTORY
Jill Haglund

MATERIALS:

MARBLED PAPER: ANGY'S DREAMS

TAGS: OFFICE SUPPLY (COFFEE-DYED)

FRAME AND EYELETS: MAKING MEMORIES

VELLUM: MARCO'S "WISTERIA PURPLE"

WORD AND OVAL DISK: LI'L DAVIS DESIGNS

BLACK AND BROWN INKS: INKADINKADO

"DUTCH BIRTH CERTIFICATE" STAMP:
STAMPERS ANONYMOUS

TRANSPARENCY FILM: OFFICE SUPPLY

ADHESIVES: ART ACCENTZ STICKY TAPE OR
XYRON MACHINE; UHU GLUE STICK; YES! PASTE

OTHER: BUTTONS, POSTAGE,
WRINKLED COFFEE-DYED PAPER, OLD SCRIPT PAPER

INSTRUCTIONS:

Paste script paper for background and tear marbled paper for bottom border. Add postage in top right corner; dry flat. Copy photo of girls onto two sheets of transparency film; copy small photo of man onto transparency and set aside. Rub brown dye ink onto a coffee-dyed tag and stamp with black ink. Trim small transparency of man to fit lower part of tag. Punch four small holes, slip in eyelets, and glue to page.

Tape purple vellum under one of the transparencies of the girls, add wrinkled kraft paper behind that; punch four holes, place eyelets and set. Use tape to adhere the clear transparency over script. Adhere both transparencies and tags and as shown. Tape small photo under frame, glue on button and add to page.

MOTHER
Jill Haglund

MATERIALS:

DATE STAMP:
PAPERBAG STUDIOS

FRAME, EYELETS AND PEWTER "YEARS GONE BY" PLATE: MAKING MEMORIES

YELLOW OCHRE INK:
COLORBOX "CAT'S EYE"

COPPER MESH: WIRE MESH

LIVER OF SULFUR:
MAID O' METAL

COPPER TAG:
THE CARD CONNECTION

TRANSPARENCY FILM AND TAGS (COFFE-DYED):
OFFICE SUPPLY

ADHESIVES: ART ACCENTZ STICKY TAPE; GLUE DOTS INTERNATIONAL; YES! PASTE; JUDI KINS DIAMOND GLAZE

OTHER: COFFEE-DYED LACE, BUTTONS, POSTAGE, PRESSED PINE TWIG AND FLOWER, SEWING PATTERN, WRINKLED COFFEE-DYED PAPER, SCRIPT PAPERS, RULER AND AN OLD ENVELOPE

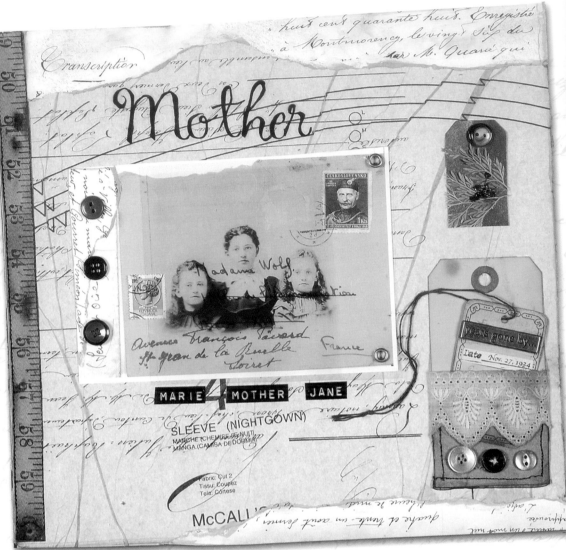

INSTRUCTIONS:

Tape a sheet of script paper to your page for the background. Paste and place sewing pattern on top of script paper. If it wrinkles, all the better; it makes for an interesting texture. Tear another sheet of script paper for the top and bottom borders; rub edges with inkpad and glue to top and bottom of page as shown. Paste ruler strip, dry and flatten. While it's drying, make tags. For the small copper tag, adhere pine twig first with flower on top; glue button over tag hole. The next tag is actually two tags; one is a pocket for the other. To make the pocket, start with a large coffee-dyed tag. Measure a piece of prepared copper mesh, a little larger then the tag's bottom half. (You can learn how to color and prepare copper with liver of sulfur in Chapter 10.) To make pocket, fold edges of copper to fit bottom of tag; wrap around sides. Use a sewing machine with a heavy-duty needle (for the copper mesh), stitch the sides and bottom with dark thread. Glue and wrap coffee-dyed lace around top of pocket; clip in place and dry. Glue on buttons. For second tag, stamp date on coffee-dyed paper, cut out and glue to tag; glue on "years gone by" plate and place in pocket of larger tag; adhere to page. Glue copper tag to page as shown. Copy photo onto transparency and place over envelope, punch holes, set eyelets and tape to page. Use glue dots to adhere buttons.

A B C D E F F G H I J K L M N O P Q R

02 08

MATERIALS:

LIBRARY CARD, OIL CERTIFICATE, SQUARE "55" AND GAME BOARD: PAPERBAG STUDIOS

STAMPS OF ALPHABET AND LITTLE BOY: PAPERBAG STUDIOS

SMALL WOODEN TILES: 7GYPSIES

LETTERS, EYELETS AND PEBBLES: MAKING MEMORIES

BLACK TAG: AMERICAN TAG

BROWN AND BLACK DYE INK: INKADINKADO

"DUTCH BIRTH CERTIFICATE" STAMP: STAMPERS ANONYMOUS

TRANSPARENCY FILM AND TAGS (COFFE-DYED): OFFICE SUPPLY

ADHESIVES: ART ACCENTZ STICKY TAPE; THE ULTIMATE! GLUE; UIIU GLUE STICK; GLUE DOTS INTERNATIONAL

OTHER: BUTTONS, RULER AND PENMANSHIP PAPER

THOMAS
Jill Haglund

INSTRUCTIONS:

Make transfer of photograph. Place transfer on a copy of an old envelope, punch holes and set eyelets. Coffee-dye penmanship paper; stamp alphabet onto blank sheet of coffee-dyed paper and cut in strips. Glue all papers to page as shown. Tape library card to page. Spray-paint button gold and press in adhesive-backed "o" pebble. Glue letters that spell "Tom" on black tag; adhere to library card. Stamp large coffee-dyed tag with small boy stamp. Glue ephemera, add buttons to bottom of tag and tape to page. Rub brown ink onto slide and stamp with black ink. Insert photo, glue and clamp. Once dry tape to page and add wooden letter tiles along with smaller tags.

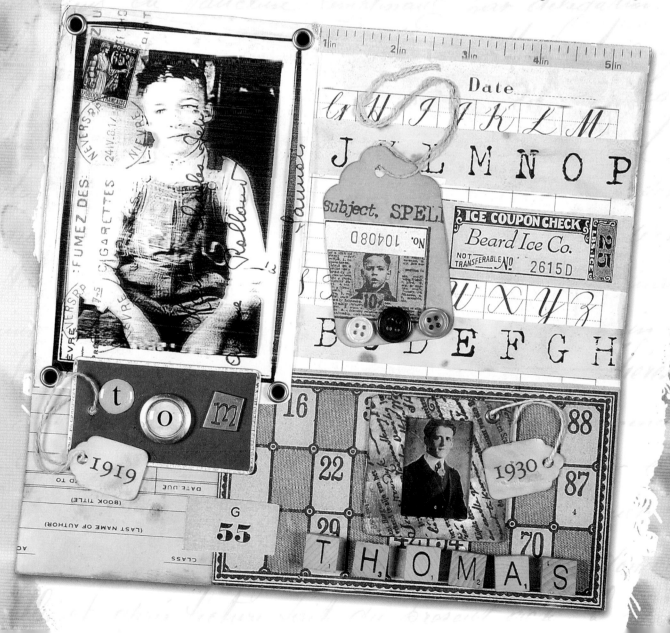

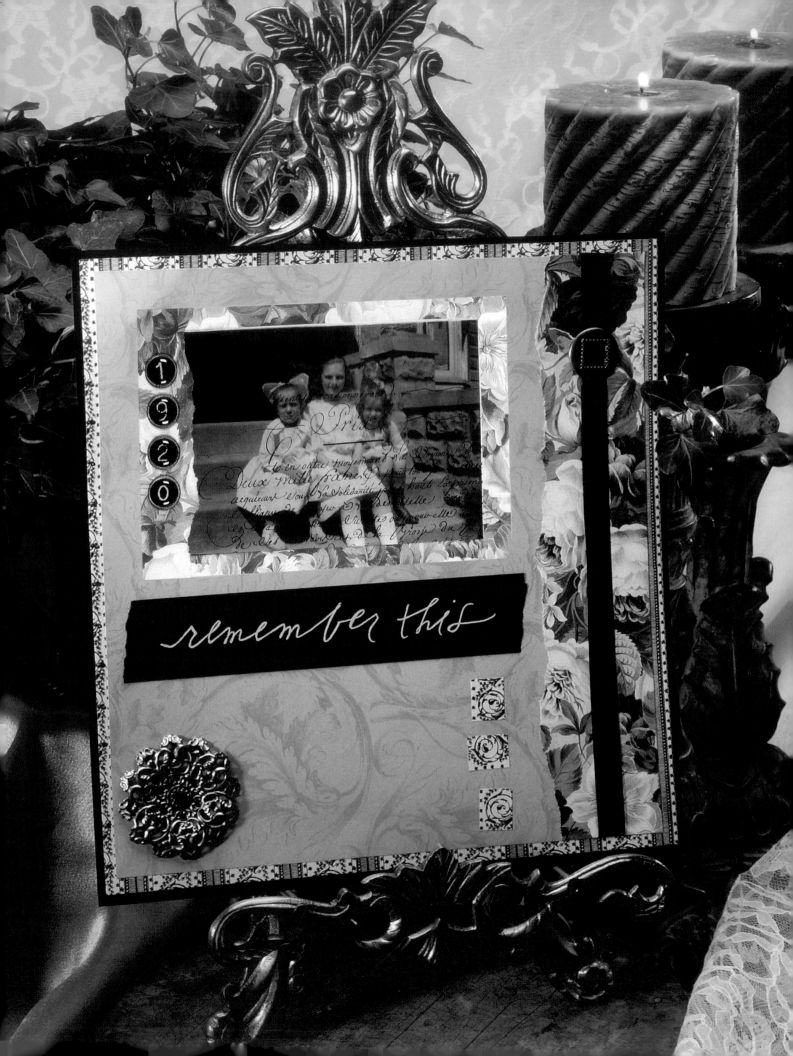

REMEMBER THIS
Roben-Marie Smith

MATERIALS:

PATTERN PAPERS: ANNA GRIFFIN

SCRIPT RUB-ON WORDS: MAKING MEMORIES

RIBBON CHARM, BUBBLE DIGITS AND DISCS: LI'L DAVIS DESIGNS

BLACK SNAP: MAKING MEMORIES

SILVER CHARM: ANIMA DESIGNS

BLACK CARD STOCK: LOCAL CRAFT STORE

TRANSPARENCY FILM: OFFICE SUPPLY

ADHESIVES: ART ACCENTZ STICKY TAPE; ELMER'S GLUE STICK; E-6000

OTHER: RIBBON AND SCRIPT PAPER

INSTRUCTIONS:

Glue two complementary pattern papers to black card stock. Tear a piece of floral paper for border. Copy photo onto transparency and tape to a piece of script paper layer to the floral pattern and then to the page. Rub script words onto black card stock; glue all to page. Adhere three squares of pattern paper. Thread ribbon through charm and attach to floral border. Insert numbers into discs and add to left side of transparency. Glue snap in the center of round silver embellishment. Note: Use a strong adhesive, such as E-6000 or Aleene's Tacky Glue, to adhere large embellishments.

[mem·or·ies]
that which is created as present becomes past

PIECES OF FAMILY HISTORY

Jill Haglund

MATERIALS:

TRANSPARENCY FILM: OFFICE SUPPLY

GOLD CLIPIOLA: STAMPINGTON & COMPANY

RUBBER STAMP: STAMPERS ANONYMOUS AND PAPERBAG STUDIOS

"REMEMBER" STAMP: INKADINKADO

FRAME: MAKING MEMORIES

BRONZE INK: COLORBOX "CAT'S EYE"

BROWN INK: INKADINKADO

ACRYLIC PAINTS: FOLKART BY PLAID

TAGS: OFFICE SUPPLY (COFFEE-DYED)

ADHESIVES: ART ACCENTZ STICKY TAPE; YES! PASTE; THE ULTIMATE! GLUE; JUDI KINS DIAMOND GLAZE; VELLUM TAPE

OTHER: PUZZLE PIECES, BUTTONS, BINGO CHIP, SCRIPT PAPER AND VINTAGE CANCELED CHECK

INSTRUCTIONS:

Paste script paper on page for background; paste check to center of page. Copy two photos onto transparencies. Tape one to text on left side of page, position the other over the check. Glue bingo chip "36" to top right corner of check. Dry flat. Place reduced photo in metal frame, glue on button and tape to page as shown. Paint puzzle pieces; dry, stamp and glue to page.

To make tag, adhere small photo under clear vellum with vellum tape, stamp "Remember" in brown ink on the bottom. Fold a piece of torn, textured paper over the top of the tag and glue to back. Rub textured paper with bronze inkpad; tuck vellum piece underneath the front. Sew across the top of tag to secure all layers. Add clip and button to top of tag. Place pressed flower on the bottom and cover with glaze. Stamp date and number; cut out and glue to small tag. Adhere all tags.

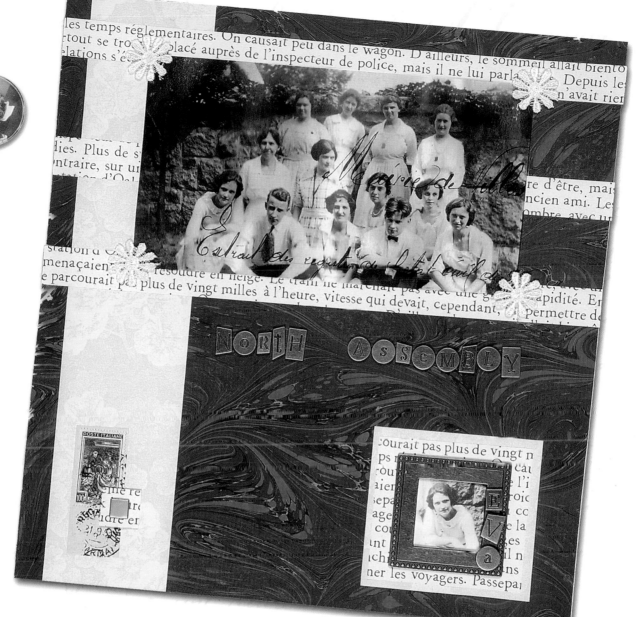

NORTH ASSEMBLY

Roben-Marie Smith

MATERIALS:

MARBLED PAPER: ANGY'S DREAMS

PRINTED WORD PAPER IN RED AND IVORY: THE CREATIVE BLOCK

PATTERN PAPER: ANNA GRIFFIN

TRANSPARENCY FILM: OFFICE SUPPLY

PEWTER LETTERS, SQUARE BRAD AND FRAME: MAKING MEMORIES

POSTAGE STAMP STICKERS: NOSTALGIQUES BY REBECCA SOWER

ADHESIVES: ART ACCENTZ STICKY TAPE; UHU GLUE STICK; THE ULTIMATE! GLUE

OTHER: LACE FLOWERS AND BLACK TEXT

INSTRUCTIONS:

Glue pattern paper and three strips of word paper to page. Copy photo onto sheet of transparency film and tape to script paper then to page. Add lace flowers to corners as shown. Glue frame with photo to two squares cut from the red text and the pattern paper; glue to page. Glue pewter letters to the side of the frame. Add brads. Last, adhere stamps and pewter letters to page.

JACKSON FAMILY REUNION
Jill Haglund

MATERIALS:

MARBLED PAPER: ANGY'S DREAMS

PRINTED WORD PAPER IN BLACK AND BROWN: THE CREATIVE BLOCK

TRANSPARENCY FILM: OFFICE SUPPLY

TAG: OFFICE SUPPLY (COFFEE-DYED)

SCRAPBOOK TWILL AND BOOK LABEL: 7GYPSIES

WORDS AND OVAL DISCS: LI'L DAVIS DESIGNS

ADHESIVES: ART ACCENTZ STICKY TAPE; ELMER'S GLUE STICK; THE ULTIMATE! GLUE

OTHER: ANTIQUE BUTTON, HEMP

INSTRUCTIONS:

Enlarge the photograph onto a sheet of transparency film. Handwrite names loosely on a piece of bond paper. Position names under transparency and tape together. Tear marbled and letter paper for top and bottom borders apply paste and smooth down. Attach book label to page. Add brads and prepare insert to label. Glue strip of scrapbook twill to bottom. Press words into metal oval discs and glue to tag; thread antique button to top and secure with glue, let dry. Wrap bottom of tag with hemp. Tape the tag to top of page in the center.

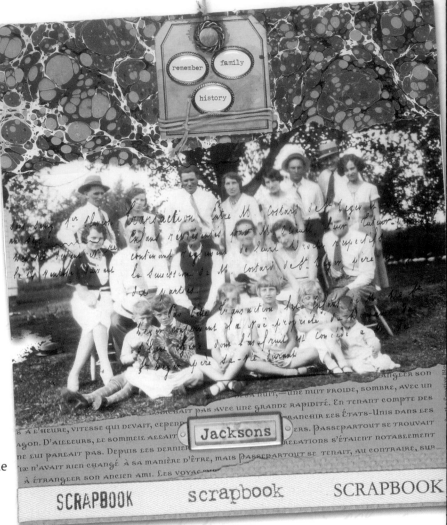

MARIANNE: 1933 TO 1952
Jill Haglund

MATERIALS:

MARBLED AND SCRIPT PAPER: TWEETYJILL PUBLICATIONS

BLACK PAPER: CANSON

OTHER PAPERS: 7GYPSIES "CALENDRE" AND "LESSON"

TEAL CARD STOCK: MARCO'S

TRANSPARENCY FILM: OFFICE SUPPLY

TAGS: OFFICE SUPPLY (COFFEE-DYED)

DATE STAMP: MAKING MEMORIES

RUBBER STAMP: INKADINKADO BY DAWN HAUSER

WORDS ON TAGS: CREATIVE IMAGINATIONS "SHOTZ" BY DANELLE JOHNSON

SNAPS: MAKING MEMORIES

PEWTER "MOM" PLATE: K&COMPANY

ADHESIVES: ART ACCENTZ STICKY TAPE; YES! PASTE; THE ULTIMATE! GLUE

OTHER: PLASTIC PHOTO SLIDE, OLD FRENCH NEWSPAPER AND PLASTIC CRYSTAL WATCH

INSTRUCTIONS:

Cut strips of paper and paste onto page in this order: Lesson, Script, Calendre, Script and Marbled. Enlarge photo onto a sheet of transparency film. Place small black and white photo inside watch crystal. Glue watch crystal to tag, add pewter "Mom" plate and stamp "1952" as shown; glue to page. Attach large transparency to script with tape; punch holes and set snaps. Stamp circular tag and add to page. Insert photo and glue down black photo slide. For tags along the bottom, layer teal card stock, French newspaper and black paper to tags; add words on top of layers. Tape all tags along bottom.

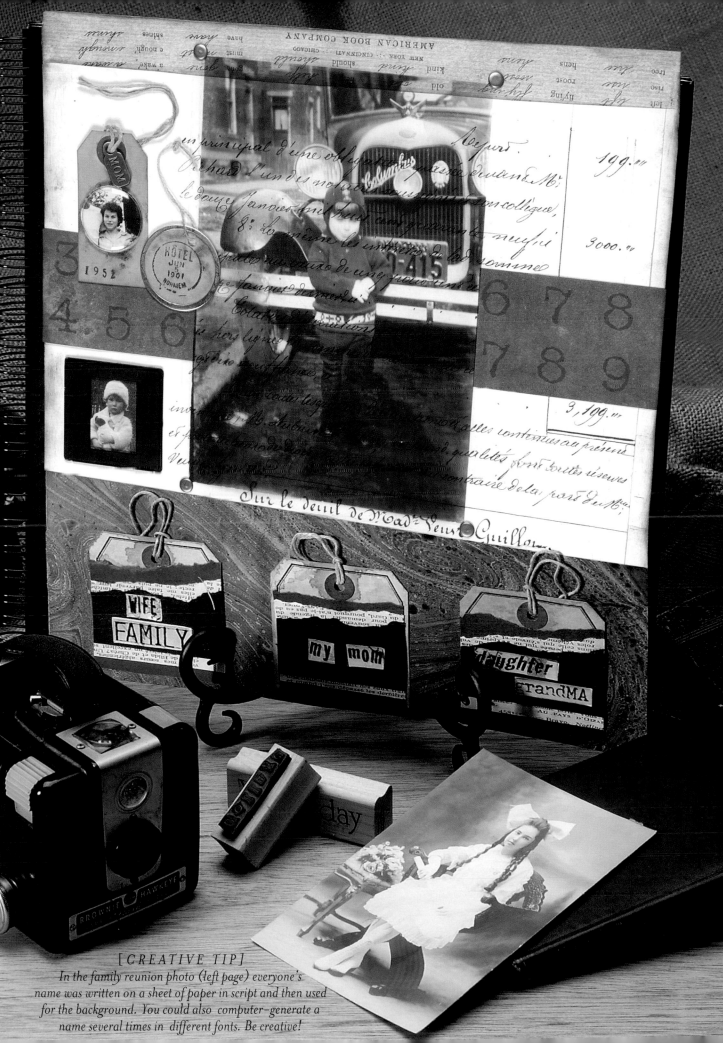

[CREATIVE TIP]
In the family reunion photo (left page) everyone's
name was written on a sheet of paper in script and then used
for the background. You could also computer-generate a
name several times in different fonts. Be creative!

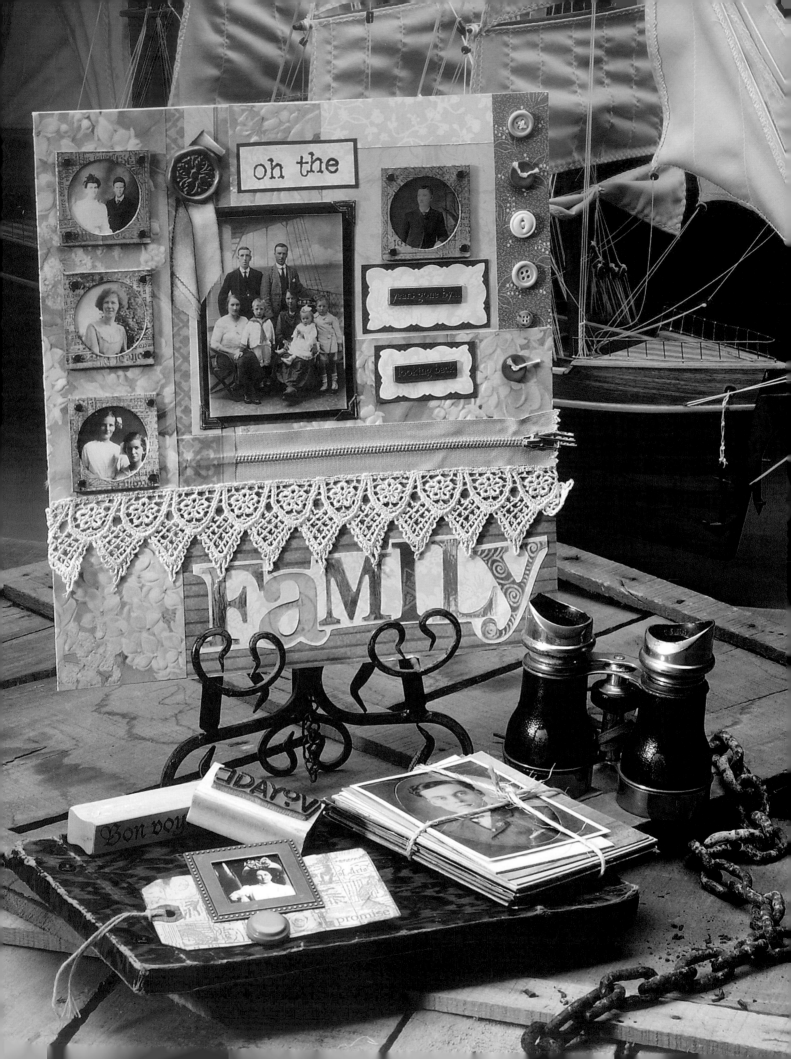

FRAMED

A picture tells a thousand words. Frame it, and it sings! There are infinite varieties of frames to choose from: big frames, little frames, pewter frames, slide frames, coin pocket frames, painted frames, simple frames, ornate frames, corner frames, circular frames, inked and stamped frames, frames with transparencies, tags as frames … well, you get the picture!

OH, THE FAMILY

Joey Long

MATERIALS:

PAPERS: ANNA GRIFFIN; K&COMPANY; CREATIVE IMAGINATIONS

STAMP: STAMPERS ANONYMOUS

ALPHABET STAMPS: PAPERBAG STUDIOS

SLIDE FRAMES AND PEWTER WORDS: MAKING MEMORIES

GOLD PHOTO CORNERS: CANSON

BRADS: MAKING MEMORIES

FAUX WAX SEAL: SONNETS

GREEN INK: VIVID

BLACK INK: STAZON

ZIPPER: JUNKITZ

DECORATIVE SCISSORS: FISKARS

ADHESIVES: ART ACCENTZ STICKY TAPE; THE ULTIMATE! GLUE; UHU GLUE STICK; GLUE DOTS INTERNATIONAL

OTHER: BUTTONS, CROCHETED LACE AND MATCHING THREAD, BLACK AND GREEN CARD STOCK

INSTRUCTIONS:

Arrange and glue papers on page in patchwork fashion. Sew lace across bottom third of page with crochet thread. Rub green ink on slide frames and stamp with black ink. Place a small photo in each frame, poke holes in corners of frames and insert miniature brads. Tape to page.

Layer large photograph and attach to page with photo corners. Tape pewter words on lightly patterned paper trimmed with decorative scissors, then to green card stock; add zipper. Cut out letters to spell "family," glue to lightly patterned card stock, cut out again and glue under bottom edge of lace. Stamp "oh, the" on lightly patterned paper, layer to green card stock, glue to page and dry flat. Attach faux wax seal over a short length of silk ribbon. Use glue dots to adhere buttons along right edge of paper.

forever (for·ev´·er) 1. for always, without end 2. without the bonds of time; eternal

cherish (cher´·ish) 1. to hold dear 2. to treasure, adore, value and love 2. to keep deeply in mind

enduring (en·door´·in) 1. lasting; permanent 2. continuing on until the end

legacy (leg´·e·se) something passed through a family, handed down as from an ancestor

Perth N.B. Apl 16 1909

Lawson Esq

memory

lasting

time

THREE

Roben-Marie Smith

MATERIALS:

OLD LETTER AND FLINCH CARD: PAPERBAG STUDIOS
FIBERS: ADORNMENTS
DEFINITIONS: MAKING MEMORIES
STABILO CRAYONS: DUOTONE
INK: ADIRONDACK
ACRYLIC PAINT: DECOART

ADHESIVES: ALEENE'S TACKY GLUE; GLUE DOTS INTERNATIONAL

OTHER: WASHERS, MASKING TAPE, BUTTONS, HOLE REINFORCEMENTS, PLASTIC PHOTO SLIDES, WATERCOLOR PAPER

INSTRUCTIONS:

Paint watercolor paper with brown and ivory acrylic paints and let dry. Place hole reinforcements onto page, sponge over with brown ink and remove. Glue old letter, Flinch card and definitions to page. Draw on the page around the letter, card and definitions with brown crayon, then smudge with fingers. Glue photos to page under plastic slides. Add words to tags and glue to page. Use small pieces of masking tape to hold strings in place. Poke holes in page on either side of the Flinch card. Pull fiber through with washers attached and tape to back to hold ends in place. Use glue dots to secure washers. Add buttons to page.

THE HAIRCUT
Roben-Marie Smith

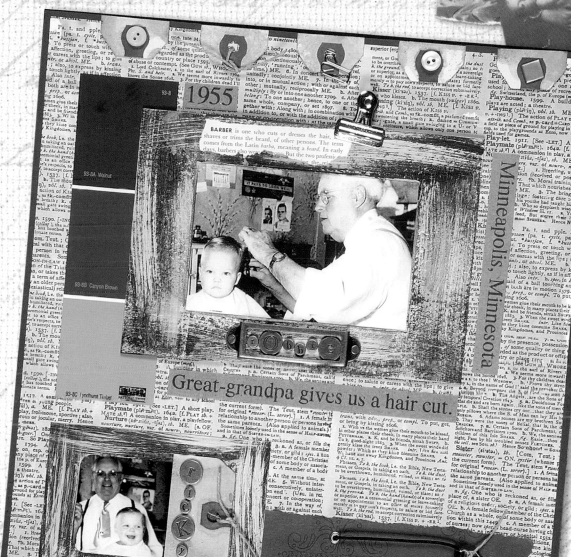

MATERIALS:

PATTERN PAPER, STEEL END AND BLACK ELASTIC CORD: 7GYPSIES

CARD STOCK, PEWTER BRAD AND BLACK SNAP, METAL LABEL HOLDER, ALPHABET CHARMS: MAKING MEMORIES

WALNUT INK: ANIMA DESIGNS

BULLDOG CLIP AND REGAL CLIP: OFFICE SUPPLY

TWINE AND MAT FRAMES: LOCAL CRAFT STORE

TAGS: AMERICAN TAG

ACRYLIC PAINT: GOLDEN

EYELETS AND WASHERS: COFFEE BREAK DESIGNS

ADHESIVES: THE ULTIMATE! GLUE; GLUE DOTS INTERNATIONAL

OTHER: OLD BUTTONS, PAINT CHIP

INSTRUCTIONS:

Stain paper and tags with walnut ink, following directions on jar. Trim and glue paper to card stock. Cut small tags and add buttons, twine, brad and clip as shown. Glue all to page. Layer torn paper to page. Paint frames and let dry. Add definition to largest frame with a bulldog clip. Glue to page over photo.

Use glue dots to adhere pewter label and alphabet charms to bottom of frame. Glue smaller frame to page over photo. Trim and glue medium tag to side of photo. Add alphabet charms. Punch two holes and set with eyelets and washers at bottom right of page. Thread black elastic cord through steel end and tie with twine; set to page with black snap. Poke the ends of the elastic through eyelet holes to secure. Computer-generate text and add to page. Tuck paint chip under mat as shown.

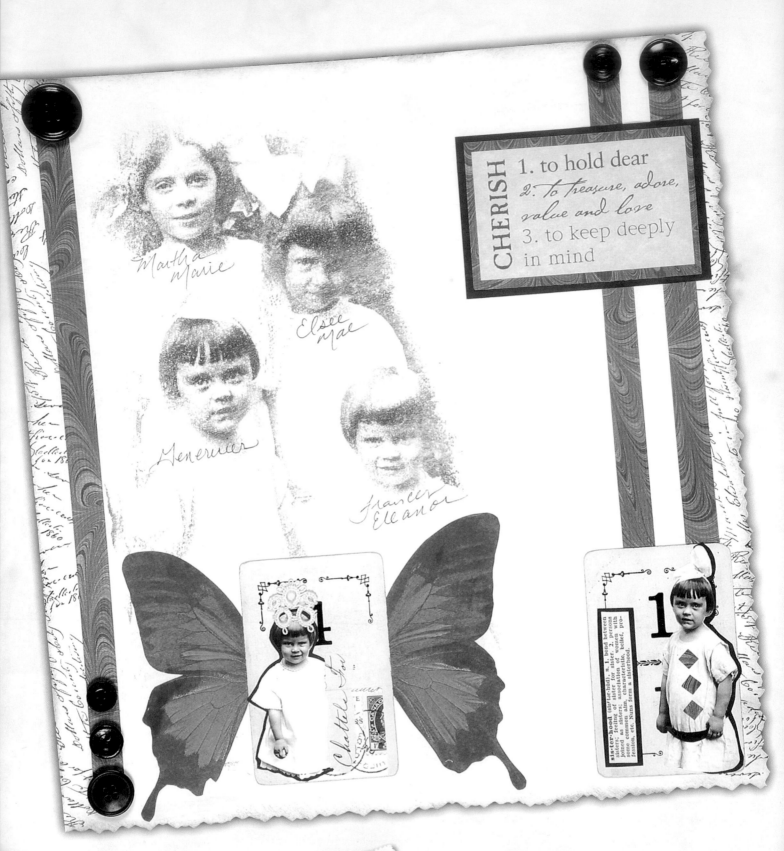

CHERISH 1. to hold dear 2. to treasure, adore, value and love 3. to keep deeply in mind

Martha Marie

Elsie Mae

Genevieve

Frances Eleanor

CHERISH
Roben-Marie Smith

The pictures you see on these pages are not charcoal sketches, despite their artful appearance! They are transfers … soft, dreamy images made from copies of photographs. The process is surprisingly simple. Start by making a copy of your photo on a machine that uses toner. In a well-ventilated area, assemble your copy, some cotton balls, acetone (available at hardware stores) and the page, tag or surface to use for your transfer.

Place the copy of your photo face down on the new surface. Rub firmly and smoothly with a cotton ball dampened with acetone. Cover the entire area. Repeat, pushing out toward the edge while pressing down. You might want to peek under the edge to make sure you are rubbing hard enough, but be careful not to shift the copy or your transfer will be blurry.

When finished, lift off the copy to see your artwork! Use as is, or enhance with colored pencils, watercolors or photo tinting pens.

MATERIALS:

PAPER EPHEMERA AND FLINCH CARDS:
PAPERBAG STUDIOS

RUBBER STAMP: PAPERBAG STUDIOS

DEFINITIONS: MAKING MEMORIES

ACRYLIC PAINT: GOLDEN

INK: STAZON

DECKLE EDGE SCISSORS: FISKARS

ADHESIVES: THE ULTIMATE! GLUE;
UHU GLUE STICK; GLUE DOTS INTERNATIONAL

OTHER: LACE, BUTTONS, ACETONE, COTTON
BALL, DICTIONARY PAGE AND MARBLED PAPER

INSTRUCTIONS:

Enlarge and photocopy an image and place face down on page. Using pure acetone and a cotton ball, rub until transfer is made. Dry brush the page with ivory acrylic paint. Cut bottom and right edges with deckle scissors. Sponge edges of pages with black ink. Stamp script on left and right edges of page with black ink. Glue strips of marbled paper to page. Embellish Flinch cards with images from a smaller copy of the same photo, lace, ephemera and definition from dictionary. Cut out butterfly wings from a photo, copy and glue to page with cards. Layer "Cherish" definition to marbled paper and card stock; glue to page. Add buttons to page as shown.

HOW TO DO TRANSFERS

HOW TO DO ACETONE TRANSFERS

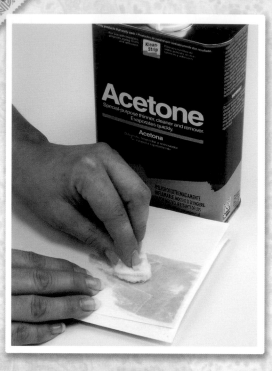

STEP 1

Place a laser color copy of the image you want to transfer upside down onto the paper, tag or scrapbook page. Line up the two papers exactly like you want them and hold in place with your fingertips. Saturate a cotton ball with acetone. Start in the center of the image to be transferred and push cotton ball firmly out to the sides. The paper turns darker when it is wet, and will be a good indicator when to re-saturate the cotton ball (most likely several times). As you work, turn the two papers until they have rotated a full 360 degrees, continuously pushing outward to the edges firmly. While you do this process, don't let the papers shift or you image will not be clear. You may have to do this full rotation more then one time; peek to see if image is transferring.

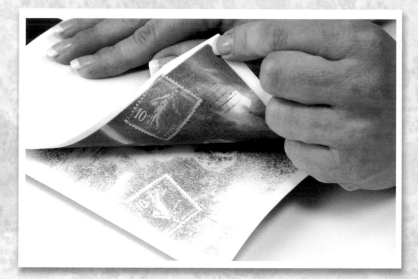

STEP 2

Once the image is how you want it, you can lift the copy off. You may prefer a lighter, more dreamy look or rub a little longer for a dark and clearer replica. Just don't overdo the rubbing. The paper may tear or start to "pill", creating little pieces to separate and ruin your transfer. Try several; practice makes perfect!

LOVE
1. strong liking or affection of something or someone 2. a passionate affection from one person to another 3. the object of such affection; a sweetheart

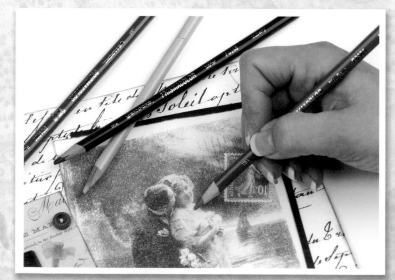

STEP 3

If using colored pencils, make sure you apply light pressure.

[CREATIVE TIP]

Different type papers accept transfers in unique ways; try cold-pressed watercolor and printmaking papers for the most clear and sharp transferred image. White and manila tags work great too.

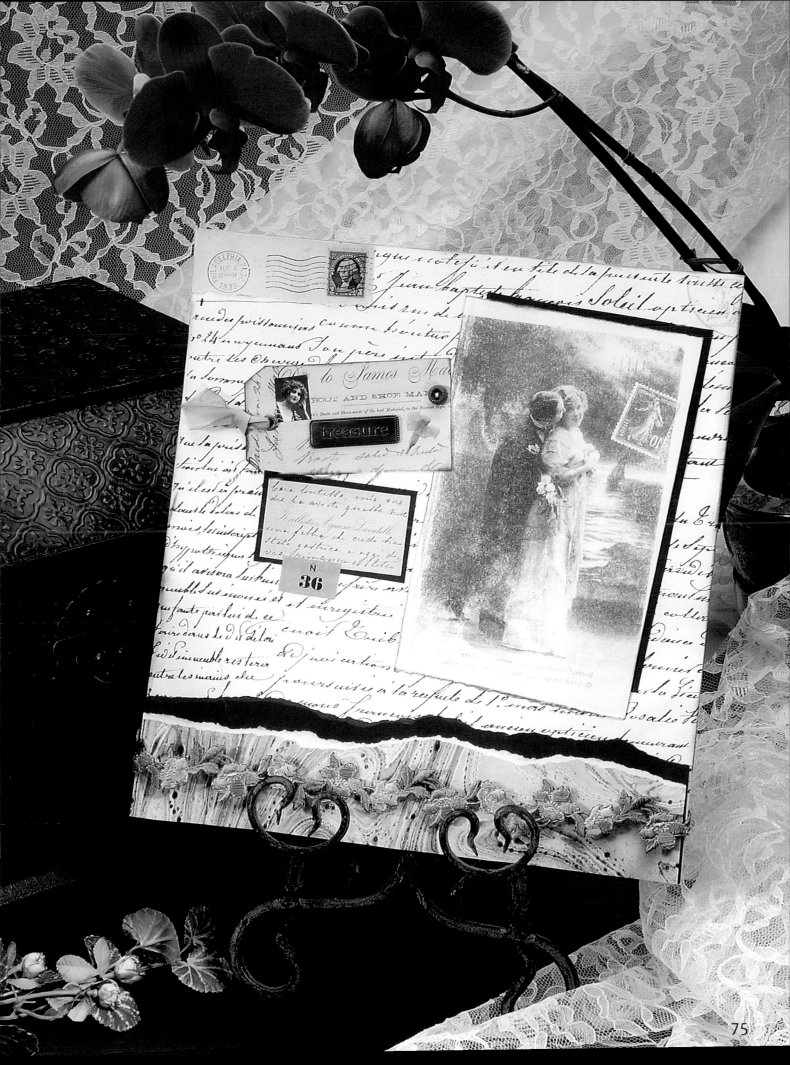

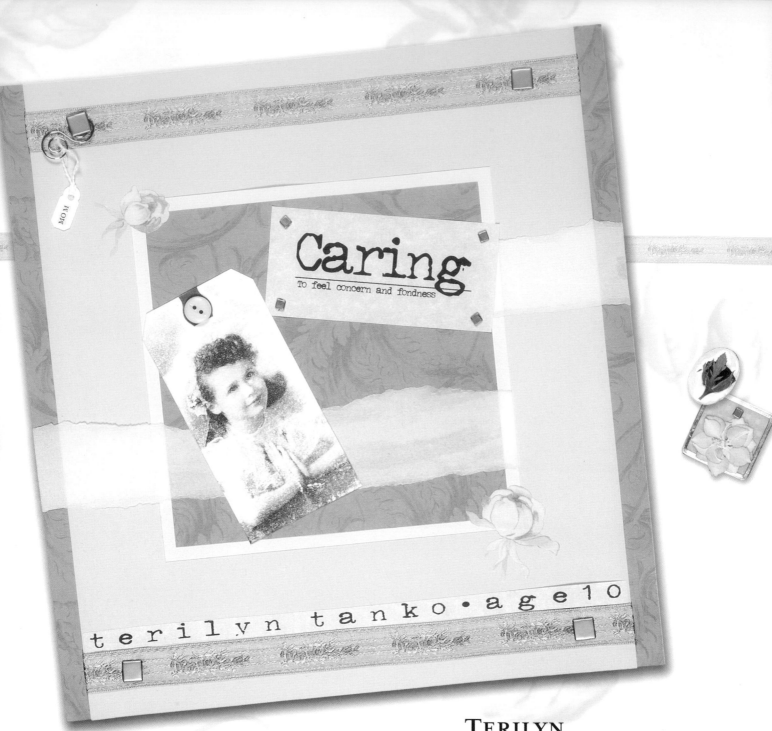

Caring

To feel concern and fondness

terilyn tanko · age 10

INSTRUCTIONS:

Computer-generate text. Transfer photo onto tag with transfer pen, following directions on packaging. Layer papers and card stock to page as shown. Tear and sponge vellum with pink dye ink. Layer to page with tag and glue small button to hole in top of tag. Glue floral trim to page and add brads to corners. Glue "mom" to small jewelry tag and slip on silver clip; attach to page with brad. Glue computer-generated text to page. Set "Caring" definition with four small brads. Place flower stickers on opposite corners of photo.

TERILYN

Roben-Marie Smith

MATERIALS:

PATTERN PAPER: ANNA GRIFFIN

CARD STOCK BRADS: MAKING MEMORIES

FLOWER STICKERS AND VELLUM: K&COMPANY

DOUBLE SPIRAL CLIP: 7GYPSIES

INK: ANCIENT PAGE DYE INK

CHARTPACK TRANSFER PEN: LOCAL CRAFT STORE

TAGS: AMERICAN TAG

ADHESIVES: ALEENE'S TACKY GLUE; GLUE DOTS INTERNATIONAL

OTHER: BUTTONS, TRIM

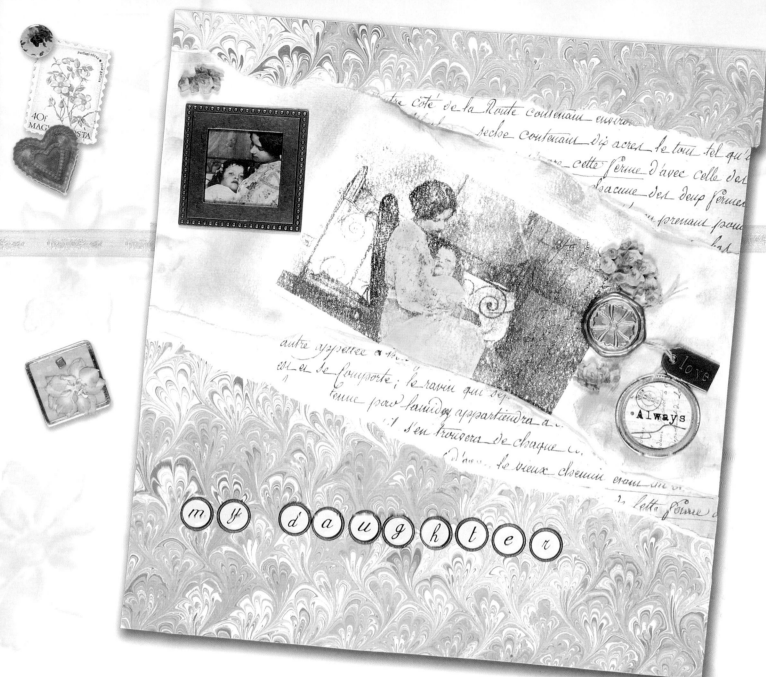

FOR MY DAUGHTER

Jill Haglund

MATERIALS:

MARBLED AND SCRIPT PAPER: TWEETYJILL PUBLICATIONS

BUBBLE TYPE AND DISCS: LI'L DAVIS DESIGNS

PEWTER FRAME: MAKING MEMORIES

ROSE AND TAUPE INKPADS: COLORBOX "CAT'S EYE"

PEWTER "LOVE" TAG: K&COMPANY

"FLOWERS" AND "ALWAYS" GRAND ADHESIONS: K&COMPANY

TAG: OFFICE SUPPLY (COFFEE-DYED)

FAUX WAX SEAL: SONNETS

ADHESIVES: THE ULTIMATE! GLUE; UHU GLUE STICK

OTHER: ACETONE, COTTON BALL

INSTRUCTIONS:

Transfer copy of photo onto page. Rub two colors of ink around the transfer. Tear script paper for top and bottom of page and adhere around transfer. Next, layer torn marbled paper over script and extend to page edges, trim if necessary. Pull down edges of script paper to make it roll and lightly rub rolled edges with inks. Place smaller copy of photo in a frame, glue to page. Place flowers above frame. Press the adhesive bubble type, spelling "My Daughter," into the circular metal discs; glue to page as shown. Put wax seal, flowers, and pewter "love" tag on the top right corner of photo transfer. Last, glue circular "always" tag.

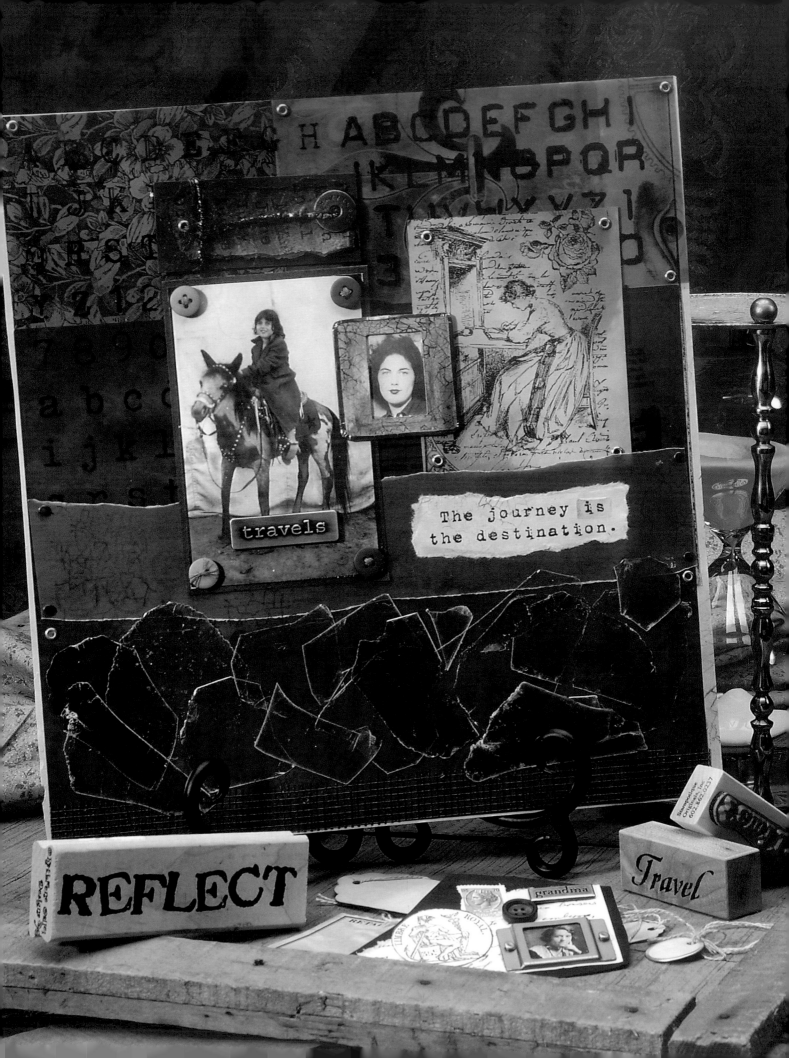

Textures add depth to collage, whether in the form of layers, papers, tags, transparencies, buttons, fibers, mesh, metal plates or whatever. Even the tiniest of eyelets has texture it's smooth. Now that you are a collage artist, you are drawn to textured items; you *have* to touch them. Smooth, rough, sharp, ridged, bumpy - pile them on! You can't overdo it. Relax and have fun, just be sure to step back and look to make sure you are still showcasing the photographs within your artwork. Continue to explore, discover, and use some of the ideas for textured materials in this chapter.

PONY RIDE
Joey Long

MATERIALS:

BROWN PAPER: CANSON

GLOSSY CARD STOCK: MARCO'S "KROMEKOTE"

DAVINCI COLORED TRANSPARANCY: MAGIC SCRAPS

VELLUM AND BLACK CARD STOCK: LOCAL CRAFT STORE

STAMP OF LADY AT DESK: INKADINKADO

CRACKLE CUBE STAMP: STAMPERS ANONYMOUS

ALPHABET RUBBER STAMP PLATE AND "THE JOURNEY IS THE DESTINATION": PAPERBAG STUDIOS

FLOWER BORDER RUBBER STAMP: MAGENTA

INKS: ANCIENT PAGE DYE INKS

PEARL EX COLORED POWDERS: JACQUARD PRODUCTS

BRONZE "TRAVELS" PLATE AND WASHER WITH WORD: LI'L DAVIS DESIGNS

SLIDE FRAME, PAGE PEBBLE, BRADS AND EYELETS: MAKING MEMORIES

MICA AND COPPER FOIL TAPE: USARTQUEST

BRONZE MESH: MAGIC MESH

STYLUS: COLORBOX

FIBERS: ADORNMENTS

ADHESIVES: ART ACCENTZ STICKY TAPE; THE ULTIMATE! GLUE; PERFECT PAPER ADHESIVE; SCOTCH VELLUM TAPE

OTHER: COFFEE-DYED PAPER

INSTRUCTIONS:

Step 1. Use stylus to swirl glossy paper with dye inks, then stamp with a flower border and tape to top left corner of page. Tape the colored transparency to the right. Adhere a large piece of brown paper to bottom half of page.

Step 2. Copy the alphabet index onto a transparency; tape entire sheet to the upper part of page. Tear rust vellum strip and place across page, stamp with crackle cube stamp. Add mesh to the very bottom to act as a border.

Step 3. Using a stylus, swirl yellow, green and rust inks onto another piece of glossy card stock. Stamp lady in black ink. For small art above photo, mix Pearl Ex with Perfect Paper Adhesive and rub onto a small piece of black card stock. Tear around edge, stamp and layer onto cut teal paper. Place eyelets, thread fiber, add washer and tie. Attach all eyelets and brads to page as shown.

Step 4. Mount the photograph onto brown card stock, then to page; add buttons and "travels" plate. Computer-generate font and copy onto coffee dyed paper. Stamp "The journey ...," rub ink on edges and adhere to page. Place small square page pebble over "is." Rub Pearl Ex onto slide and stamp with crackle cube, insert photo, tape all edges with copper foil and glue to page. Brush bottom of page with Perfect Paper Adhesive and layer on the mica; adding adhesive as needed.

TEXTURES: FABRIC, FIBERS, MICA, MESH & MORE

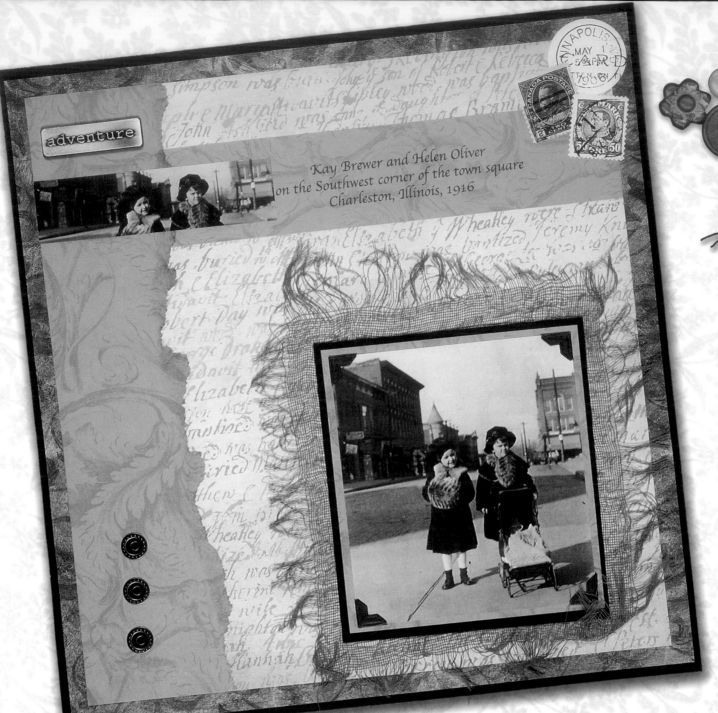

Kay Brewer and Helen Oliver
on the Southwest corner of the town square
Charleston, Illinois, 1916

TOWN SQUARE
Roben-Marie Smith

INSTRUCTIONS:

Glue pattern papers to page. Adhere "adventure" plate to page with glue dots; set rivets (like eyelets) at bottom left corner and add stickers to top right of page. Computer-generate text and print onto pattern paper; glue to page. Make a duplicate of photo, cut and glue a portion of it to page. Layer main photo to papers with photo corners; glue to page over mesh fabric.

MATERIALS:

PATTERN PAPER: SCRAP EASE; ANNA GRIFFIN

RIVETS: CHATTERBOX

POSTAGE STICKERS: NOSTALGIQUES BY REBECCA SOWER

BRONZE "ADVENTURE" PLATE: LI'L DAVIS DESIGNS

PHOTO CORNERS: CANSON

ADHESIVES: THE ULTIMATE! GLUE; UHU GLUE STICK; GLUE DOTS INTERNATIONAL

OTHER: MESH FABRIC

FRIENDS
Roben-Marie Smith

MATERIALS:

PATTERN PAPER: DAISY D'S; K&COMPANY; ANNA GRIFFIN

CARD STOCK AND EYELETS: MAKING MEMORIES

SAFETY PINS: LI'L DAVIS DESIGNS

TAGS: AMERICAN TAG

RUBBER STAMPS: PAPERBAG STUDIOS

TWILL: WRIGHTS

EXPRESSO DYE INK: ADIRONDACK

WOOD BEAD LETTERS AND TWINE: LOCAL CRAFT STORE

ADHESIVES: THE ULTIMATE! GLUE; UHU GLUE STICK

OTHER: FABRIC, BUTTON, UPHOLSTERY TACK

INSTRUCTIONS:

Sponge tags with dye ink and stamp with rubber stamps. Add pictures, pattern paper, fabric, eyelets, twine, pins, and tack to tags. Tear and layer pattern paper to page as shown. Glue tags to page. Spell "friends" with letter beads, thread with twine and glue to page. Set eyelets on both ends of twine and tie off.

WONDER
Roben-Marie Smith

MATERIALS:

BLACK PAPER WITH WHITE SCRIPT: 7GYPSIES

GREEN PAPER WITH LARGE BLACK SCRIPT: K&COMPANY

OTHER PAPERS: ANNA GRIFFIN; DAISY D'S

BLACK CARD STOCK: MAKING MEMORIES

WHITE TAG: ANIMA DESIGNS

STICKER: CREATIVE IMAGINATIONS

EYELETS: MAKING MEMORIES

SAFETY PINS, WORD AND OVAL DISCS: LI'L DAVIS DESIGNS

MUSLIN AND EMBROIDERY FLOSS: LOCAL CRAFT STORE

ADHESIVES: THE ULTIMATE! GLUE; YES! PASTE; GLUE DOTS INTERNATIONAL

OTHER: FRENCH LABEL, BUTTONS, BEADS AND AN OLD POSTCARD

INSTRUCTIONS:

Make a copy of the old postcard photo. Add green script background to page; tear additional papers. Fray a large piece of muslin and glue to page; mount postcard photo. Layer torn papers. Cut three small squares from black card stock and glue to page. Cut three smaller pieces from copy of postcard and layer to black squares. Glue smaller pieces of frayed muslin to page with safety pins and beads; add buttons and "wonder" bubble.

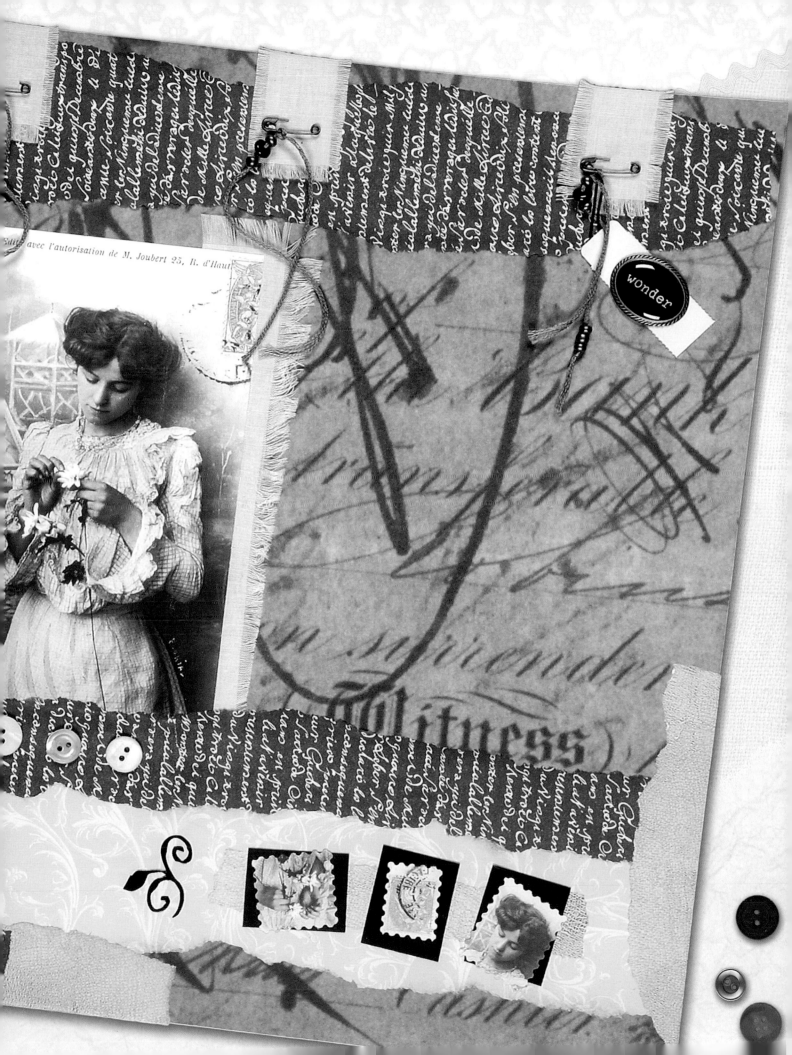

wonder

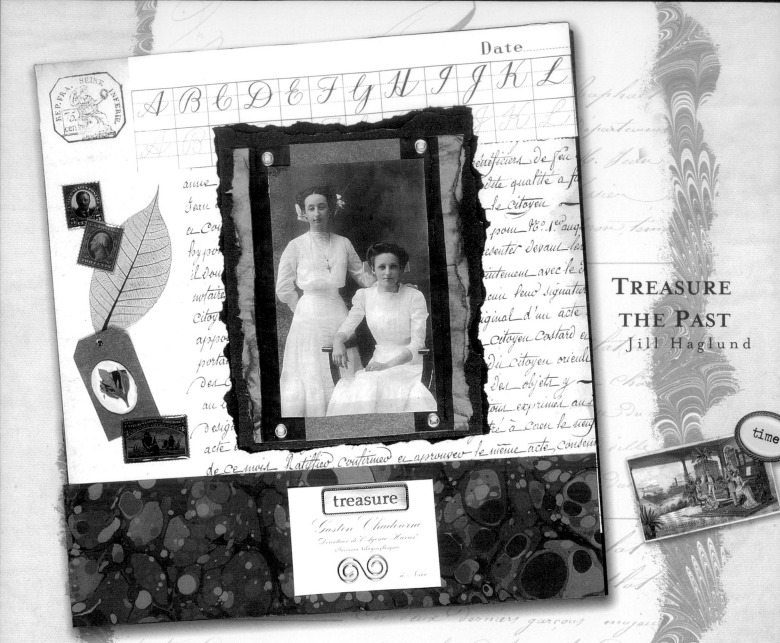

TREASURE THE PAST
Jill Haglund

MATERIALS:

MARBLED PAPER: PAPER PASSIONS

FRENCH BUSINESS CARD: PAPERBAG STUDIOS

BLUE PAPER: MARCO'S DARK BLUE "STARDREAM"

POSTAGE: K&COMPANY

PEWTER "TREASURE" PLATE: LI'L DAVIS DESIGN

CLEAR PEBBLE AND EYELETS: MAKING MEMORIES

SKELETON LEAF: BLACK INK

COPPER TAG: THE CARD CONNECTION

COPPER MESH: WIRE MESH

LIVER OF SULFUR: MAID-O'-METAL

DOUBLE SPIRALE CLIP: 7GYPSIES

ADHESIVES: ART ACCENTZ STICKY TAPE; THE ULTIMATE! GLUE; YES! PASTE

OTHER: PRESSED ROSE, BLACK THREAD, WRINKLED KRAFT PAPER AND PENMANSHIP STRIP

INSTRUCTIONS:

Adhere script paper for background; paste marbled paper to border bottom of page. Paste business card onto bottom of page, add clip to card as shown. Glue pewter "treasure" plate above card. Place penmanship strip at the top as indicated. To assemble tag, place rose onto a small white piece of paper and press clear pebble on top and trim; glue pebble to copper tag, put on left side of page and add leaf. Create a mat for the photo by first preparing a 5" x 4" piece of copper. Cut it a little larger than the photograph; fold over the side edges and tape strip of copper paper in the center. Tear a piece of wrinkled kraft paper just larger than copper piece and tape. Trim the top and bottom edges as shown, and sew the sides using black thread. Next, place the entire piece against the blue paper. Mark the size you want to tear (a little larger than the kraft paper) with a pencil, turn over and tear side without pencil mark - tear so the black shows. Tape to kraft paper; punch holes through all the layers, add silver eyelets, flip over and set. Tape the entire piece onto the page.

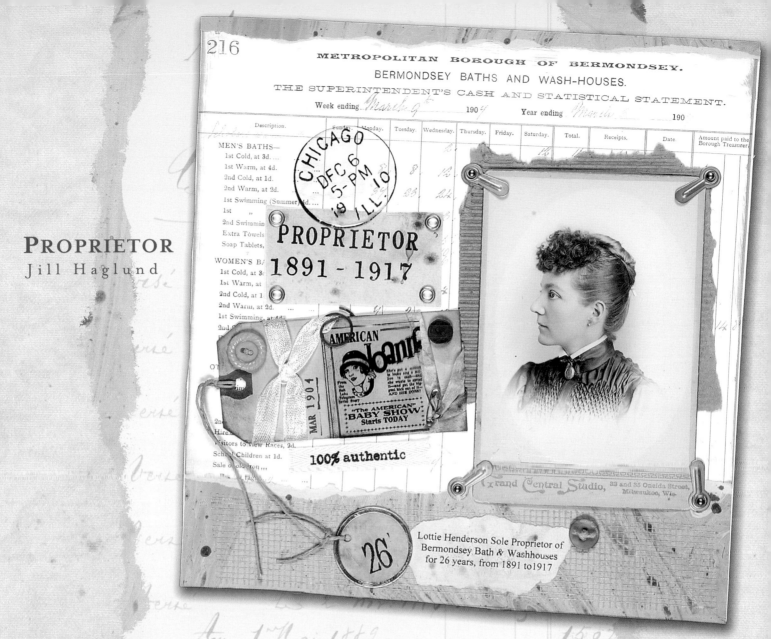

PROPRIETOR

Jill Haglund

INSTRUCTIONS:

Paste bath and warehouse paper onto page, dry and flatten. Stamp "Proprietor" and dates onto coffee-dyed paper. Cut out and attach to page with eyelets. Press "Chicago" onto page. Cover tag with London Times transparency; stamp "26" onto circular coffee-dyed tag. Paste torn, marbled paper to bottom of page, add mesh. Computer-generate name and information onto coffee-dyed paper, tear out and adhere to page with glue stick. Mark, punch and place photo turn; flip over and slip on washer, bend prongs flat. Wrap tag with ribbons; add clip and buttons. Stamp with date stamp and tape to page.

MATERIALS:

MARBLED PAPER: ANGY'S DREAMS

BATH AND WAREHOUSE PAPER: STAMPERS ANONYMOUS

CORRUGATED PAPER: LOCAL CRAFT STORE

TRANSPARENCY: 7GYPSIES

CHICAGO CIRCLE POST: K&COMPANY

TWILL WORD AND BRASS PHOTO TURNS: 7GYPSIES

SMALL DATE STAMP AND EYELET: MAKING MEMORIES

ROLLING ALPHABET AND NUMBER STAMPS: JUST RITE FROM BLACKBIRD STUDIOS

GOLD CLIPIOLA: STAMPINGTON & COMPANY

RUBBER STAMP "26": CLAUDINE HELLMUTH

GREEN MESH: MAGIC MESH

TAGS: LOCAL CRAFT STORE (COFFEE-DYED)

ADHESIVES: ART ACCENTZ STICKY TAPE; YES! PASTE; ELMER'S GLUE STICK; GLUE DOTS INTERNATIONAL

OTHER: COFFEE-DYED PAPER, BUTTONS, RIBBON

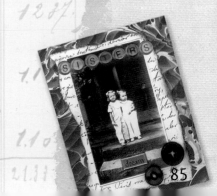

85

HOW TO STAIN COPPER MESH WITH LIVER OF SULFUR

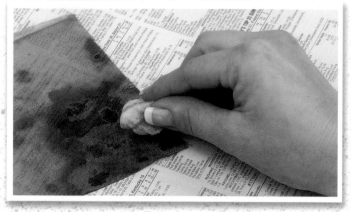

STEP 1

Place a piece of copper mesh on newspapers. Pour a small amount of liver of sulfur onto a cotton square. Rub randomly over the mesh and until it turns partially black.

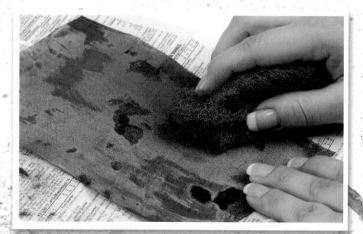

STEP 2

Scrub the mesh with 100-grit steel wool to achieve desired color.

STEP 3

Position photo, trim copper a little larger than photograph, double fold over all sides. Secure corners with eyelets. It's now ready for your page.

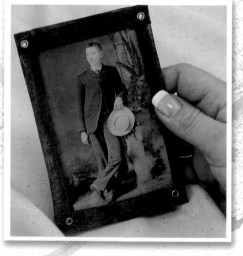

Note: Be very careful when handling copper mesh; the edges can prick your fingers.

I LOVE LITTLE CHILDREN

Joey Long

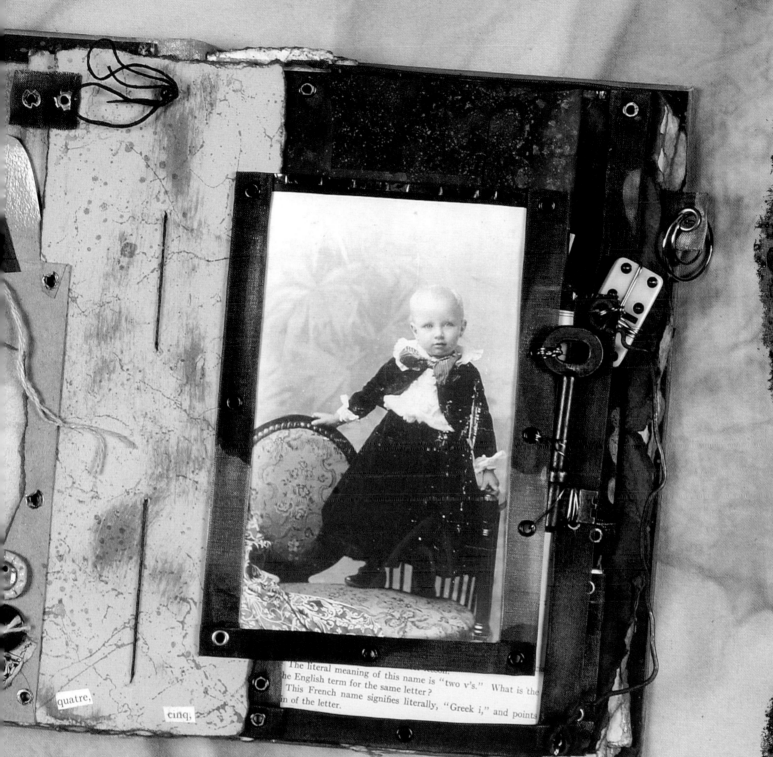

The literal meaning of this name is "two v's." What is the
he English term for the same letter? This French name signifies literally, "Greek i," and points
n of the letter.

quatre,

cinq,

MATERIALS:

CHILDREN'S FACES RUBBER STAMPS: PAPERBAG STUDIOS

PHOTO CORNERS: CANSON

INKS IN VARIOUS COLORS: COLORBOX "CAT'S EYE"

BLACK INK: MEMORIES INKPAD

FRAME FRAGMENT RUBBER STAMP: STAMPERS ANONYMOUS

TAGS (COFFEE-DYED): OFFICE SUPPLY

FIBERS: ADORNMENTS

ADHESIVES: ART ACCENTZ STICKY TAPE; UHU GLUE STICK

OTHER: BUTTONS, BLACK CARD STOCK, COFFEE-DYED CARD STOCK

INSTRUCTIONS:

Create a pocket from coffee-dyed card stock; use eyelets to attach it to the torn scrapbook page. Make tag from black card stock, attach photo with photo corners, thread fibers and tie; tuck into pocket. Stamp frame in black ink and computer-generate sentiment, tear both and age with ink. Stamp little faces onto small coffee-dyed tags. Collage elements as shown. Add buttons. See previous page for instructions to create right hand page.

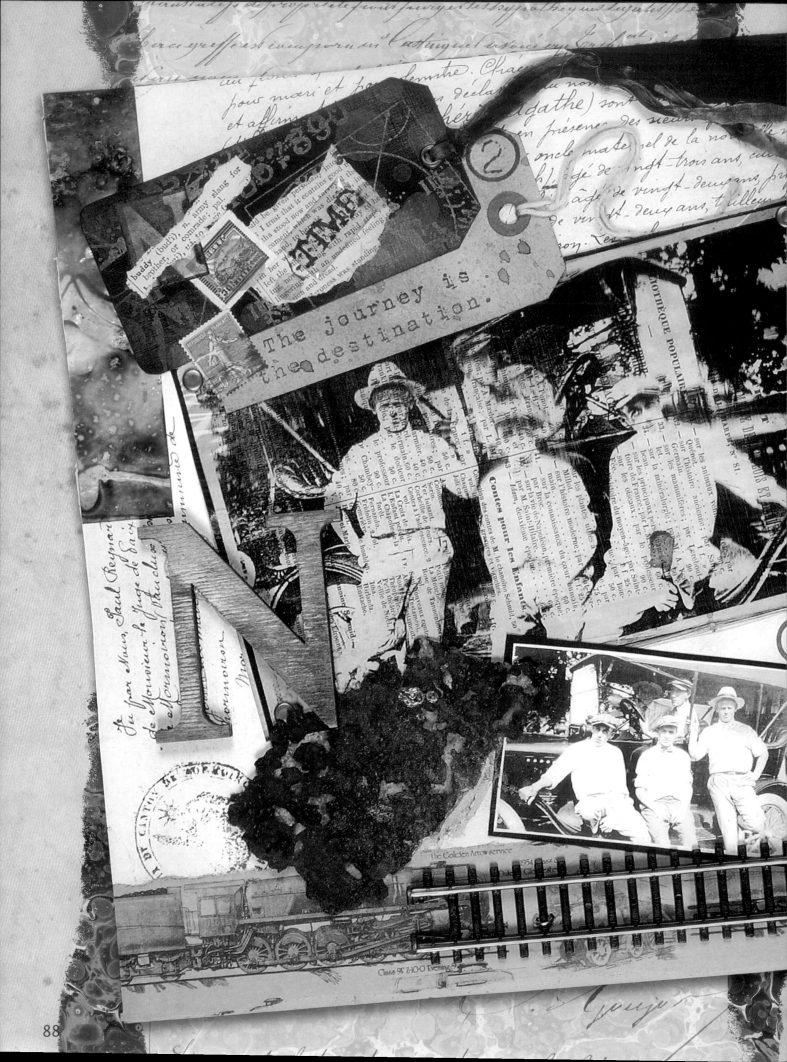

The journey is the destination.

THE JOURNEY
Joey Long

MATERIALS:

BLACK LINEN PAPER: MARCO'S

GLOSSY CARD STOCK: MARCO'S "KROMEKOTE"

RUBBER STAMPS "2", "8" AND "THE JOURNEY IS THE DESTINATION": PAPERBAG STUDIOS

NUMBER LINE RUBBER STAMP: TREASURE CAY

CIRCLES RUBBER STAMP: IMPRESSION OBSESSION

EYELETS, PACE PEBBLE AND SNAPS: MAKING MEMORIES

ADHESIVE "TIME": CREATIVE IMAGINATIONS "SHOTZ" BY DANIELLE JOHNSON

PEARL EX COLORED POWDERS: JACQUARD PRODUCTS

PINATA INKS: USARTQUEST

MINI-ADDITIONS TAG TEMPLATE: C-THRU RULER COMPANY

LARGE WOODEN LETTER "N": LOCAL CRAFT STORE

TAGS AND TRANSPARENCY: OFFICE SUPPLY

FIBERS: ADORNMENT

ADHESIVES: ART ACCENTZ STICKY TAPE; YES! PASTE; E-6000

OTHER: COFFEE-DYED MAGAZINE, NEWSPAPER AND DICTIONARY PAGES, PLASTIC WRAP, POSTAGE STAMPS, TRAIN GIFT WRAP, MODEL TRAIN TRACK, PIECE OF RUSTED METAL AND SCRIPT PAPER

INSTRUCTIONS:

Copy enlarged photo onto transparency sheet and layer on top of magazine page. Attach print to transparency with snaps and tape to page. Rub "N" with Pearl Ex powders. Drip inks onto glossy card stock, place crumpled plastic wrap on top and let dry; cut small strip for upper left corner. Stamp coffee-dyed tag with "The journey..." and "2." Trace the tag template onto black linen, punch hole and add eyelet. Use paste to collage dictionary definition, old postage, and rubber stamp images as shown. Press "TIME" onto tag and rub with Pearl Ex. Slip fibers through eyelet and tape tags onto transparency. Tear gift wrap, mat smaller photo and tape both to bottom of page. Stamp "8" between photos as shown. Press flat and dry overnight. The next day, glue train track, "N" and rusted metal to page using E-6000. Weight and dry overnight.

[CREATIVE TIP]
This page is well suited for the cover of a scrapbook, perhaps one on vacations. Due to its bulky nature, it is not recommended as an inside page.

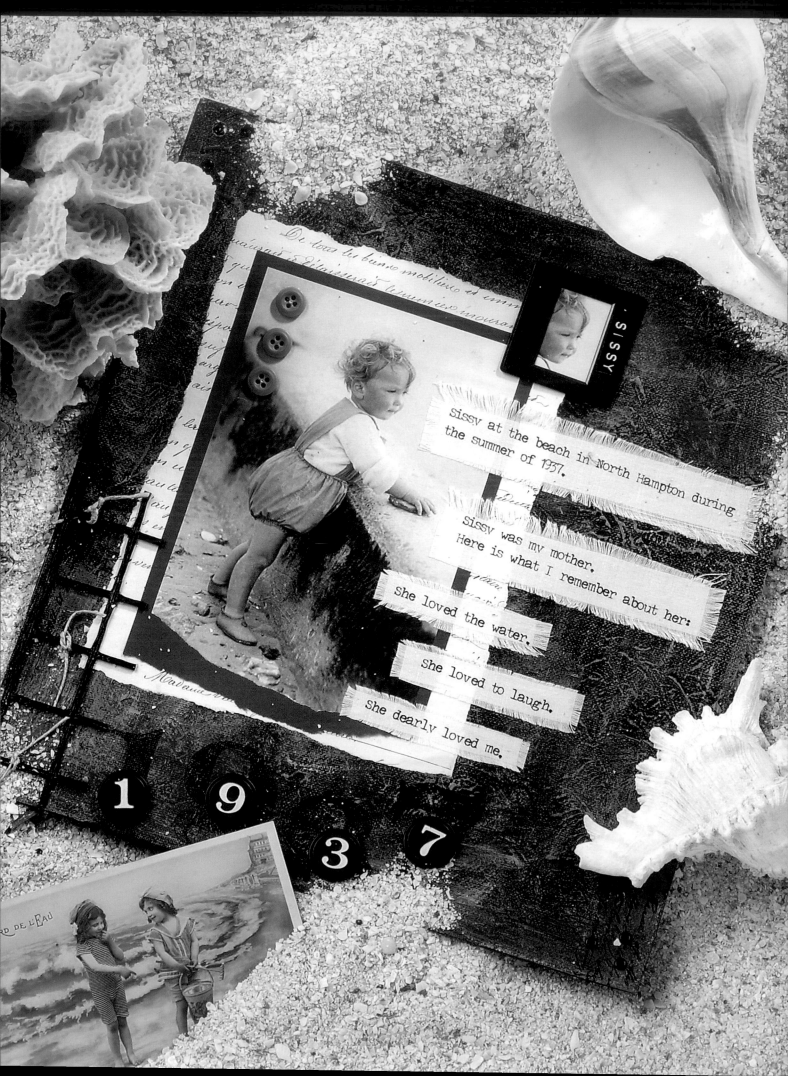

Sissy at the beach in North Hampton during the summer of 1937.

Sissy was my mother. Here is what I remember about her:

She loved the water.

She loved to laugh.

She dearly loved me.

SISSY

1937

CHAPTER

Words can be soft, kind, reflective, alive, sweet, passionate, gentle, sassy or soothing. Your words are your "voice," and they're important! What you write in your scrapbooks will speak to future generations; *how* you write it will touch their hearts.

Don't worry about spelling, grammar or sounding scholarly; just write like you talk! Tell what you know about your family members. If you never knew them, share stories you've heard about them and cite your sources. Naturally, the "who, what, when and where" are important, but stories bring the person – and the page – to life. This chapter will provide some fun and creative ways to document the history, anecdotes and legends that are sure to be treasured for years to come.

SISSY
Roben-Marie Smith

MATERIALS:

WATERCOLOR CANVAS PAPER: FREDRIX

EYELETS and CARD STOCK: MAKING MEMORIES

RUBBER STAMPS: PAPERBAG STUDIOS AND MAVINCI'S RELIQUARY

BLACK DYE INK: STAZON

WALNUT INK AND SLIDE FRAME HOLDER: ANIMA DESIGNS

MOLDING PASTE AND BURNT UMBER ACRYLIC PAINT: GOLDEN

TWINE: LOCAL CRAFT STORE

DYMO LABELS: OFFICE SUPPLY

ADHESIVES: THE ULTIMATE! GLUE; ELMER'S GLUE STICK; GLUE DOTS INTERNATIONAL

OTHER: MUSLIN FABRIC, BUTTONS, GAME PIECE NUMBERS, PLASTIC MESH AND SCRIPT PAPER

INSTRUCTIONS:

Add molding paste to a cut piece of canvas paper and let dry. Brush burnt umber paint on page, leaving some areas lighter than others. Dab with a paper towel to lighten more. Once dry, add a wash of walnut ink. Layer picture to brown card stock and old script paper; glue to page. Insert a smaller picture of the girl into the slide frame and glue to page. Create a label and add to slide frame. Computer-generate words onto muslin; cut, fray and glue to page. Stamp background with script and numbers. Attach plastic mesh and game pieces. Add eyelets to the corners of the page.

[CREATIVE TIP]
Don't forget, TweetyJill Publications' Old Notebook Paper is perfect for writing in your vintage scrapbooks.

CREATIVE WAYS WITH WORDS

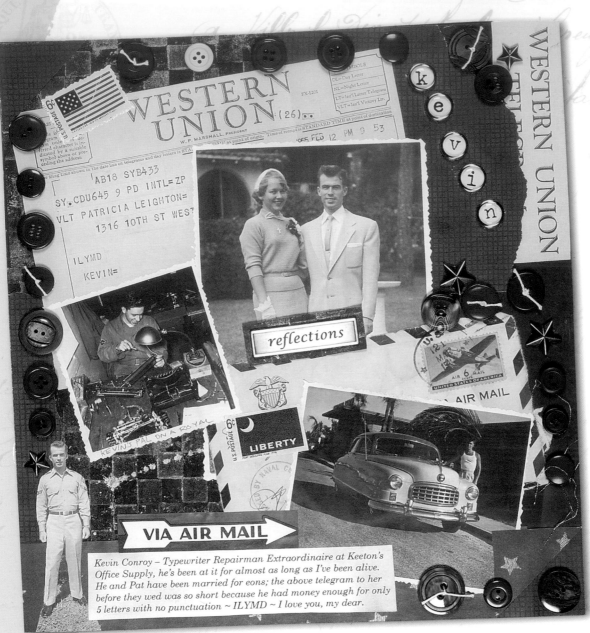

Sprinkle your page with just a few words, and it will speak volumes. You can incorporate meaningful words and phrases directly into your collage, and/or use the page that follows to journal.

Kevin Conroy – Typewriter Repairman Extraordinaire at Keeton's Office Supply, he's been at it for almost as long as I've been alive. He and Pat have been married for eons; the above telegram to her before they wed was so short because he had money enough for only 5 letters with no punctuation ~ ILYMD ~ I love you, my dear.

REFLECTIONS OF KEVIN

Joey Long

INSTRUCTIONS:

Layer torn background papers in collage fashion, as shown. Add envelope, Western Union Telegram, photos, and other ephemera. Lightly rub journaling with inkpads and adhere to page; dry flat. Make typewriter keys from frames and letters and attach to dry page. Adhere pewter "reflections" plate and all buttons.

MATERIALS:

PAPER: DAISY D'S

PEWTER "REFLECTIONS" PLATE: LI'L DAVIS DESIGNS

BLUE AND PURPLE INKS: COLORBOX "CAT'S EYE"

LETTERS: LI'L DAVIS DESIGNS

LETTER FRAMES: COFFEE BREAK DESIGNS

ADHESIVES: THE ULTIMATE! GLUE; UHU GLUE STICK; GLUE DOTS INTERNATIONAL

OTHER: GROCERY BAG DECORATED WITH ACRYLIC PAINTS, BUTTONS AND EPHEMERA

FINDLAY PARK

Jill Haglund

MATERIALS:

VIOLET PAPER: CANSON

SHIPPING TAGS: AMERICAN TAG

VELLUM TAG, SNAPS, PEWTER LETTERS, PAGE PEBBLE: MAKING MEMORIES

FRENCH BUSINESS CARD, LIBRARY CARD POCKET AND RUBBER STAMP: PAPERBAG STUDIOS

ADHESIVES: ART ACCENTZ STICKY TAPE; THE ULTIMATE! GLUE; YES! PASTE

OTHER: SHEET MUSIC, COFFEE-DYED PAPER, SMALL BUTTON, GOLD SPRAY PAINT, GOLD SAFETY PIN, RIBBON, COMPUTER-GENERATED MESSAGES TORN AND FOLDED INTO LITTLE STRIPS, MARBLED PAPER, PENMANSHIP STRIP AND BINGO CARD

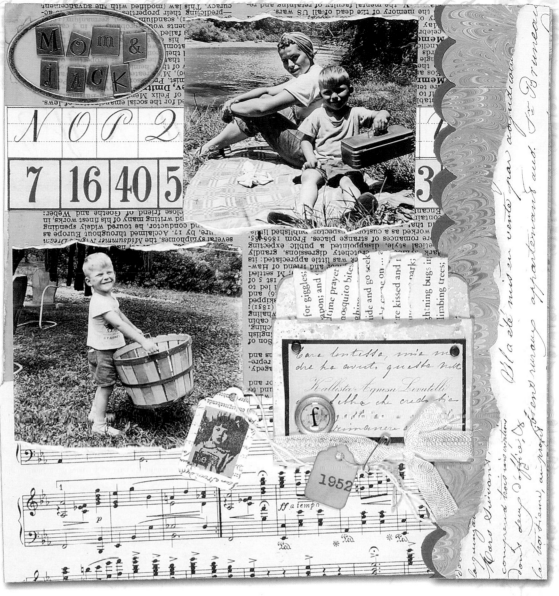

INSTRUCTIONS:

Use coffee-dyed newspaper for background. Cut marbled and violet paper with decorative scissors; trim to fit for borders. Copy bingo card onto coffee-dyed paper, cut into two strips, cut another strip from the penmanship paper and adhere across page as shown. Paste torn sheet music to bottom of page. Tear the top and bottom edges of the photos and tape to page. Tuck coffee-dyed bingo numbers under each side of top photo. Glue letters onto vellum tag. For the message pocket, coffee-dye a library card pocket. Next, copy a French business card onto coffee-dyed paper, cut and mat with black paper. Punch holes in the front of card with an Anywhere Punch. Stick in the snaps, flip over and set. Wrap card pocket with antique ribbon and tie; place a small gold safety pin to hold tags to ribbon. Spray paint a small button gold, let dry. Punch a 1/2" circle from coffee-dyed paper, press the letter" F" onto the circle, then glue circle with letter inside button ridge, to look like an old typewriter key. Stamp girl on coffee-dyed paper, trim to a small square and glue to white, stamped tag. String another small, coffee-dyed tag below card pocket. Adhere to page as shown. Dry flat. Glue "typewriter" key onto library card pocket. Tape card pocket and vellum tag on the top left corner of scrapbook page. Fold and tuck the computer-generated messages into the card pocket.

Little messages give hints about your life story...

Robert Grady Heintzelman

Born September 7, 1913

My father — gone too soon, gone before we could becomes adult friends...

He had a happy childhood for far too few years...his father died when Dad was only 7 years old, and he lost his mother when he was about 10. His sister — "Peaches", he called her — went to live with their Aunt Tillie and Uncle Charlie, and their son, Kenneth....but Dad was sent to live out his youth at

Girard College — an orphanage for boys in Philadelphia, Pa. It wasn't a bad life — local businessmen practiced altruism by providing the boys with new suits of clothes, tickets to the theater, books, and other things most boys their age couldn't afford. Poor substitutes for a warm and loving family, but it helped to soothe the empty feeling that never quite left him. When he graduated, he left Girard with mixed feelings — he was ready to start out on his own, but would miss the friends he'd made there.

He was a hard worker with an admirable work ethic. He did his best for several employers, but when he'd had enough of working for other people, he started a produce stand — with a borrowed bag of potatoes. When he'd sold all the potatoes, he repaid the kind man who'd helped him, and bought a big bag of carrots with his profit. When they were gone, he bought carrots and potatoes, and the business soon outgrew its little corner of Sparkle Market in Perrysville. He relocated to McKnight Shopping Center and expanded to include numerous employees — including Mom and my three older sisters, Patty, Sally and Bobbie. Dad made the most beautiful fruit

baskets to sell at Christmas time, gaining a name for himself but sometimes working for three days straight to keep up with the seemingly endless orders.

By the time I was 13, my sisters were all married, and his aching back could no longer handle lifting the heavy wooden crates of fruit. He sold that part of the business and opened a shop of Epicurian foods in what used to be a jewelry store. The delicate glass shelves were perfect for the beautiful jars and cans of mysterious and foreign foods. I worked in the store on Saturdays, pricing each can with a black Listo pencil, more delicate wares with a hand written label, straightening the shelves, learning to help customers. I learned from him the joys and ethics of working in retail — his mantra: "The customer is always right, Tootsie-pie, no matter if they really are or not. Treat them well and with respect, and they will remain loyal to you. You will sleep well at night — and you will keep your job." He paid me $10 for the whole day (Mother thought that exhorbitant) - and I soon discovered the principals of saving for coveted treasures.

Dad also loved nature. He loved to watch, identify and listen to birds....feed the ducks at the North Park dam on a Sunday morning... drive to Lake Erie on a whim for a refreshing mini-holiday from the city...

ROBERT GRADY HEINTZELMAN
Joey Long

MATERIALS:

ADHESIVE LETTERS: NOSTALGIQUES BY REBECCA SOWER

DARK BLUE PAPER: CANSON

RAISED DYE INKPAD: PSX "WEDGEWOOD BLUE" AND "TAUPE"

COLORED PENCILS: PRISMACOLOR

HAND-DYED SILK RIBBON: JKM RIBBON AND TRIMS

ADHESIVES: ART ACCENTZ STICKY TAPE; THE ULTIMATE! GLUE; YES! PASTE; UHU GLUE STICK

OTHER: WIRE, FIBERS, BEADS, COFFEE-DYED SHEET MUSIC, COFFEE-DYED PAPER, MARBLED PAPER, BIRD CARD AND BINGO NUMBER

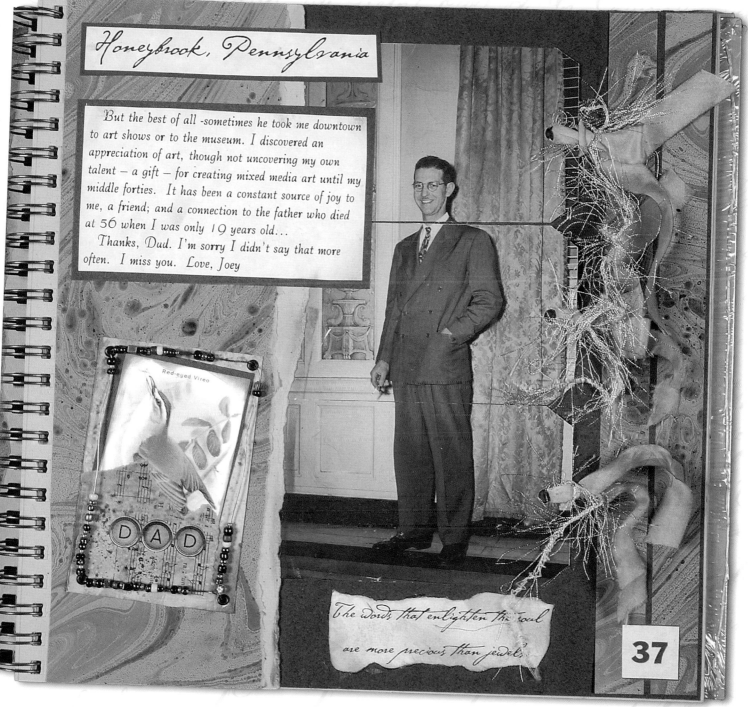

Honeybrook, Pennsylvania

But the best of all -sometimes he took me downtown to art shows or to the museum. I discovered an appreciation of art, though not uncovering my own talent – a gift – for creating mixed media art until my middle forties. It has been a constant source of joy to me, a friend; and a connection to the father who died at 56 when I was only 19 years old...

Thanks, Dad. I'm sorry I didn't say that more often. I miss you. Love, Joey

Red-eyed Vireo

D A D

The words that enlighten the soul are more precious than jewels

37

INSTRUCTIONS:

To prepare your pages, tear the first page to five inches. Cut the next page the length of your tags. Do not cut the third page. Line up three large tags, one above the other, glue on copy of photo and dry flat. Lightly tint a few elements in the photo with ink and colored pencil. Flip over all three tags onto a cutting mat, use a craft knife to cut and separate. Glue them onto second page. Cover third page with blue paper and two strips of marbled paper, leaving a bit of blue to show between the strips. Thread tags with ribbons and fibers and tie loosely. Mount bird card onto blue paper and coffee-dyed paper; set eyelets. Thread wire and run through eyelets, adding beads here and there for embellishment. Add a scrap of sheet music and the letters. Attach marbled paper to torn page; tape bird card onto page. Computer-generate journal entry, mount to blue paper, then to pages as shown. Computer-generate quote, tear it out and sponge with dye inks; adhere below tags. Add bingo number in bottom right corner.

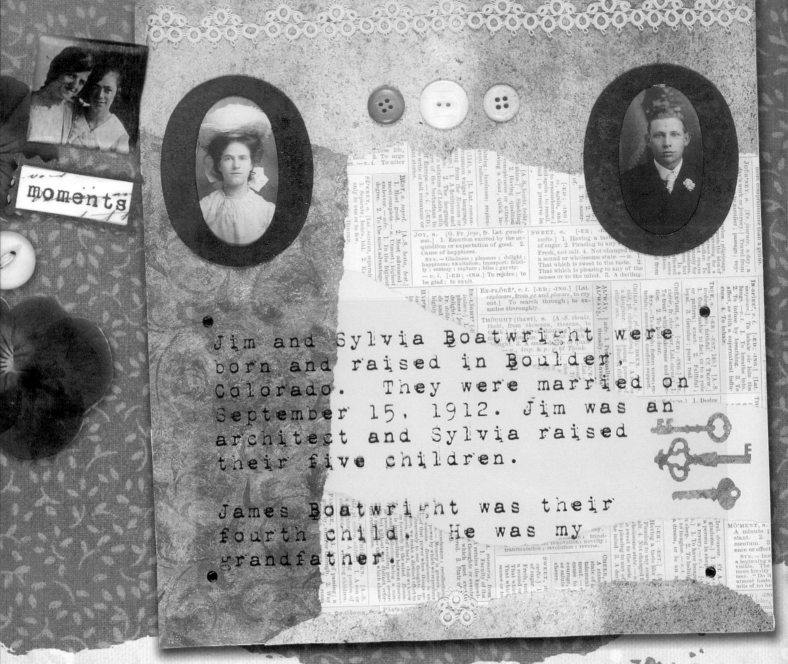

Jim and Sylvia Boatwright were born and raised in Boulder, Colorado. They were married on September 15, 1912. Jim was an architect and Sylvia raised their five children.

James Boatwright was their fourth child. He was my grandfather.

JIM & SYLVIA
Roben-Marie Smith

MATERIALS:

PATTERN PAPER: SCRAP EASE, PROVO CRAFT AND K&COMPANY

CARD STOCK AND EYELETS: MAKING MEMORIES

TRANSPARENCY FILM: OFFICE SUPPLY

METAL NUMBERS: LOCAL CRAFT STORE

KEY PUNCH: PUNCH BUNCH

ADHESIVES: UHU GLUE STICK; E-6000; GLUE DOTS INTERNATIONAL

OTHER: OLD LACE OR TRIM, BUTTONS

INSTRUCTIONS:

Computer-generate text and print onto transparency; cut to fit page. Layer pattern papers to card stock as shown. Punch keys into pattern paper and glue to page. Glue photos to upper left and right corners of page; use E-6000 to frame photos with metal numbers. Secure transparency to page with eyelets.

Use glue dots to add lace or trim and buttons to page.

Tell the story on tags …

GREAT-GREAT GRANDFATHER

Jill Haglund

MATERIALS:

PAPER: EVER AFTER SCRAPBOOK COMPANY

BRONZE "LEGACY" PLATE: LI'L DAVIS DESIGNS

"OLD GLORY," MY HERO," AND "COURAGE" STICKER PHRASES: STICKO, PHRASE CAFE

LETTERS FOR "CIVIL WAR": WORDSWORTH

BRASS BRADS AND EYELETS: MAKING MEMORIES

INKS: COLORBOX "CAT'S EYE"

STIPPLE BRUSHES: TOY BOX RUBBER STAMPS

BUBBLE TYPE: LI'L DAVIS DESIGNS

GOLD BINDING DISC: ROLLABINDERS

ARCHIVAL RECORDS: ARTIST'S PERSONAL COLLECTION FROM NATIONAL ARCHIVES

TRANSPARENCY FILM AND SHIPPING TAGS: OFFICE SUPPLY

TWINE: LOCAL CRAFT STORE

ADHESIVES: ART ACCENTZ STICKY TAPE; THE ULTIMATE! GLUE; YES! PASTE

OTHER: COFFEE-DYED PAPER, ANTIQUE AND OTHER BUTTONS

INSTRUCTIONS:

Enlarge and copy photo onto a transparency. Punch holes and use eyelets to join transparency to paper. Paste National Archive records on tags and dry flat, stipple color with brushes. Use inkpads to bring color around edges of tags; set eyelets in each. String the tags with a small length of twine, slip on an antique button and tie off twine. Adhere bottom tag onto page at a slight angle; let the rest hang. Use a spot of glue on the twine, layer bubble wrap over button and dry overnight. Copy the name from the archival records onto coffee-dyed paper. Place transparency film over it to protect it, punch with an Anywhere Punch and add brads, flip and set. For typewriter keys, punch 1/2" circles from coffee-dyed paper, apply sticky letters to circle; press into a disc and adhere to page. Add sticker phrases and letters to spell "Civil War."

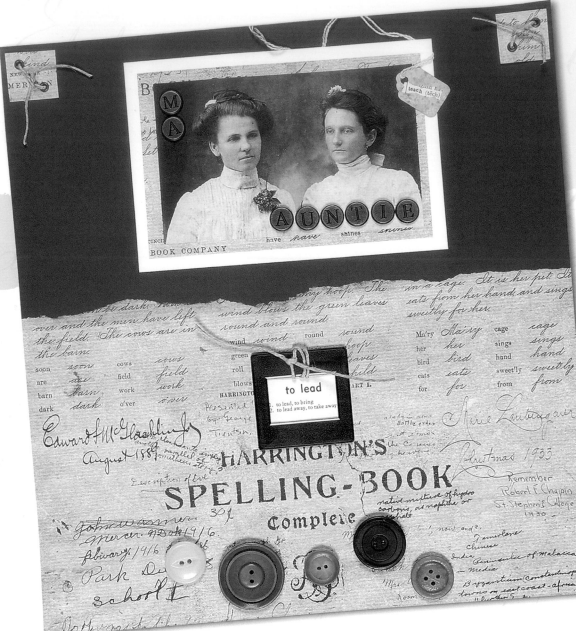

MA & AUNTIE
Roben-Marie Smith

The few words on this page tell you these two were sisters and teachers.

MATERIALS:

PATTERN PAPER: 7GYPSIES "LESSON"

CARD STOCK: MAKING MEMORIES

TAG: OFFICE SUPPLY (COFFEE-DYED)

COPPER LETTERS: K&COMPANY

SLIDE HOLDER: ANIMA DESIGN

EYELETS: MAKING MEMORIES

TWINE: LOCAL CRAFT STORE

FLASH CARD: SILVER FISHES

ADHESIVES: THE ULTIMATE! GLUE; UHU GLUE STICK; GLUE DOTS INTERNATIONAL

OTHER: ANTIQUE BUTTONS

INSTRUCTIONS:

Layer torn pattern paper over card stock then to page. Cut two small squares from pattern paper. Set two eyelets in each, tie twine through and glue both squares to page corners as shown. Layer photo to papers and glue to page. Glue small coffee-dyed tag to edge of photo, computer-generate "teach" and glue to tag. Adhere copper letters to photo with glue dots. Glue flash card definition under slide holder, wrap with twine and glue to page. Use glue dots to add buttons to bottom of page.

the boys

the journey

the boys

Date 1929

No. 5175
the Miles

FRANK TOM PETE JOE

Combine creative techniques with words...

JOHANNA HURKMAN
Roben-Marie Smith

MATERIALS:

PATTERN PAPER: EVER AFTER SCRAP-
BOOK COMPANY AND ANNA GRIFFIN

**CARD STOCK AND PEWTER NUMBER
PLATES:** MAKING MEMORIES

ADHESIVES: UHU GLUE STICK; YES!
PASTE; GLUE DOTS INTERNATIONAL

OTHER: VELLUM, TRIM, BEADS, SCRIPT
PAPER AND CANCELED CHECK

INSTRUCTIONS:

Tear and layer ephermera, papers and
pattern paper to page. Paste photo
to page and add trim down left side.
Tear embossed vellum and glue to
page along with small, flat beads.
Computer-generate journal block
and glue vertically to left side of
page. Use glue dots to adhere
pewter numbers.

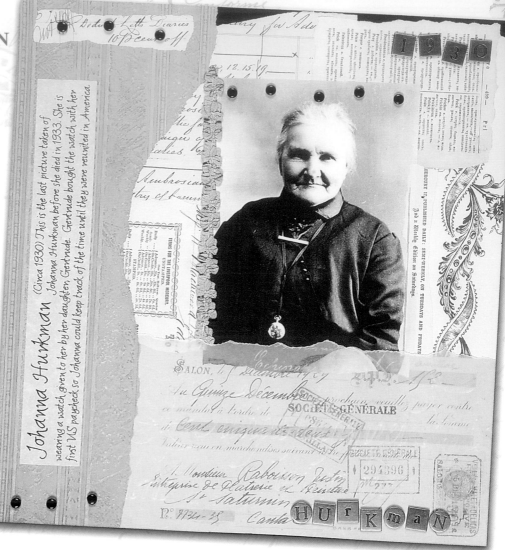

THE BOYS
Jill Haglund
(Shown on page 99)

MATERIALS:

TRANSPARENCY FILM AND TAGS: OFFICE SUPPLY

COPPER TAG: THE CARD CONNECTION

PAGE PEBBLE AND COPPER EYELETS:
MAKING MEMORIES

BRONZE BINDING DISCS: ROLLABINDERS

KEY: STAMPINGTON & COMPANY

BROWN MESH: MAGIC MESH

COPPER MESH: WIRE MESH

LIVER OF SULFUR: MAID-O'-METAL

**RUBBER STAMP AND PHOTOS
("FRAGMENT CLUB"):** PAPERBAG STUDIOS

LABEL MAKER: DYMO

ADHESIVES: THE ULTIMATE! GLUE; YES! PASTE; GLUE
DOTS INTERNATIONAL

OTHER: BUTTONS, STAMPS, BAY LEAVES, LINEN THREAD,
COFFEE-DYED PAPER, GLASSINE PAPER, KRAFT-COLORED
PAPER, GROCERY BAG AND FRENCH SCRIPT PAPER

INSTRUCTIONS:

First, prepare wrinkled kraft paper by holding a cut 12" x 12"
piece of grocery bag under tap water. Crumple up and gently
squeeze out excess water until almost dry. Repeat two or three
times, being careful not to tear the paper. Let air-dry overnight.

Next, tear a piece of kraft paper and paste to bottom of
page; layer prepared wrinkled grocery bag over top. Make
"typewriter keys" by punching 1/2" circles from coffee-dyed
paper, press letters onto circles and glue into discs. Tear script
paper and place at bottom as shown. Reduce four photos to
the same size, mat on black paper, trim and place along bottom
right. Use a label maker to print names and press above each
photo. Stamp shipping tag with "No." rubber stamp. Enlarge
photo onto a sheet of transparency film and position over
script. Attach transparency to page by punching through
all layers with Anywhere Punch, flip page and set eyelets.
Press and dry flat. Add buttons, "typewriter keys", tags
and key.

This is a leaf of
the apple tree.

This is an
apple blossom.

to recall, to remember

761

Cissie was rather less than average, probably because
she had been indifferently taught for most of her life. Also
she was very feminine, caring more about not getting ink
on her fingers or creases in her dress than about learning
French, music, or literature.

This is an apple tree.
It has roots, trunk,
branches, and leaves.
The trunk is like a
cylinder

75

232

Dorothy

Cissie

Hannah

TO RECALL

Roben-Marie Smith

*Old flash cards and the computer generated story
cut into strips of paper are inspiration for you
"To Recall" memories …*

MATERIALS:

PRINTED PAPERS: ANNA GRIFFIN AND DAISY D'S

T-PIN: OFFICE SUPPLY

OLD TEXTBOOK, NUMBER PAGES AND
FLASH CARD: SILVER FISHES

ADHESIVES: ART ACCENTZ STICKY TAPE;
THE ULTIMATE! GLUE; YES! PASTE

OTHER: MUSLIN, RIBBON, GREEN THREAD,
BUTTONS,
METAL LABEL PLATE, SHEET MUSIC
AND SCRIPT PAPER

INSTRUCTIONS:

Paste script, sheet music and old textbook papers to page.
Add torn pattern paper. Using a sewing machine, stitch around a
piece of muslin with green thread and glue to page. Glue photo
to page and add torn flash card with T-pin. Layer additional
images to bottom of page and add computer-generated names.
Glue buttons to card stock, add ribbon to end of label plate and
glue to page over buttons. Wrap ribbon to back of
page and secure with tape. Cut out words
from old textbook and glue
near large photo.

EDITIONS adventure
s extra
98 Rue Richelieu - PARIS

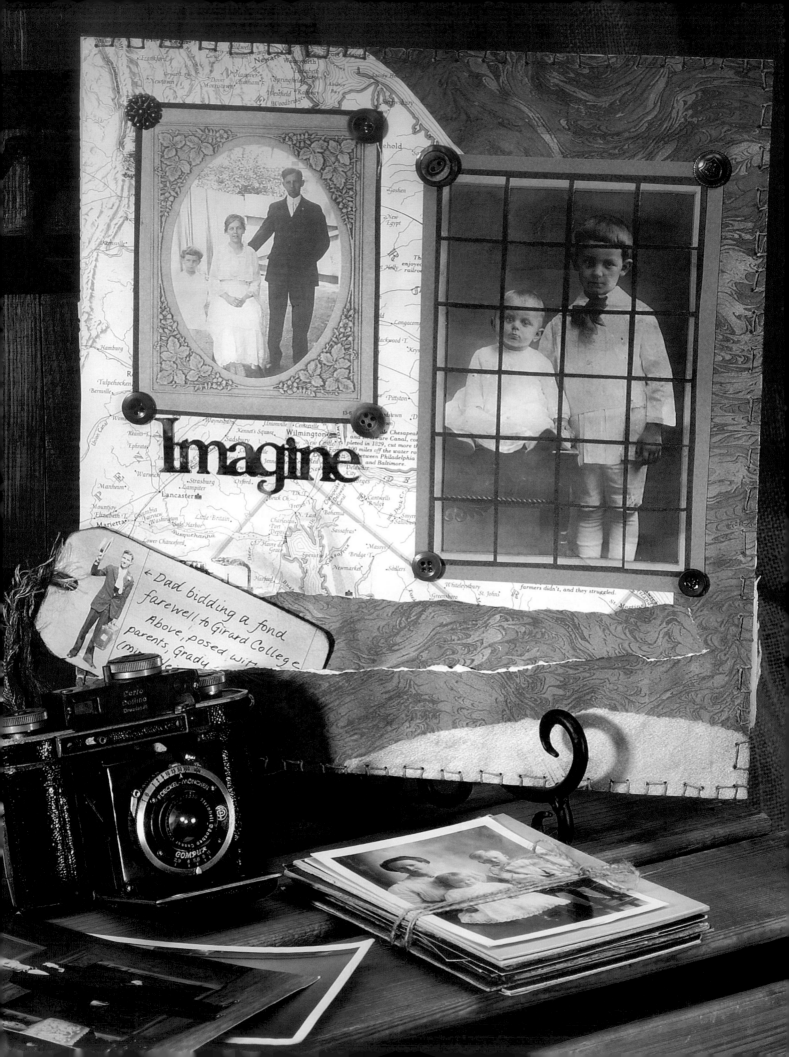

Imagine

← Dad bidding a fond
farewell to Girard College
Above, posed with
parents, Grady
(mid...

Imagine a trip through time, through a gallery of page layouts graced with your family photographs. All you have to do is visualize *your* family photos in these page designs. Let your journey inspire you to use what you've learned in the preceding chapters; let this book be your reference for years to come. Create your own family heritage scrapbooks using our ideas and yours. *Experiment … enjoy … imagine.*

IMAGINE

Joey Long

MATERIALS:

BLUE PAPER. CANSON

METAL "IMAGINE" WORD CUTOUT: MAKING MEMORIES

SHIPPING TAG: AMERICAN TAG

STIPPLE BRUSHES: TOY BOX RUBBER STAMPS

BLACK ARCHIVAL PEN: SAKURA MICRON PIGMA PEN (.03)

MAGENTA AND BLUE PINATA ALCOHOL INKS: JACQUARD PRODUCTS

FIBERS AND WAXED LINEN THREAD: LOCAL CRAFT STORE

ADHESIVES: ART ACCENTZ STICKY TAPE; THE ULTIMATE! GLUE; YES! PASTE; GLUE DOTS INTERNATIONAL

OTHER: MAP, BUTTONS AND MARBLED PAPER

INSTRUCTIONS:

Paste marbled paper and map to page as shown. Tear strips of marbled paper and scrap of gold paper; layer both on bottom edge of page. Adhere only the sides of the top marbled paper to allow room to tuck tag. Glue notebook paper to tag and stipple with dark inks. Reduce photo, cut out and adhere to tag. Journal on tag, add fibers, and tuck into the pocket you created. Mat smaller framed photograph on a layer of blue paper and tape to page. Adhere buttons to corners with glue dots. Cut blue paper a little larger than the photo of the two children. Paste photo onto light brown paper and dry flat. Cut into 1" squares and mount the squares on the blue paper, leaving a slight space in between. Adhere to tan card stock and then to page. Use glue dots to adhere buttons in each corner of the frame. Color metal word "imagine" with inks and tape to page. Punch 1/16" holes around the entire page at 1/2" intervals; thread #18 darning needle with waxed thread and sew around the edges using the punched holes as a guide.

A Journey Through the Gallery

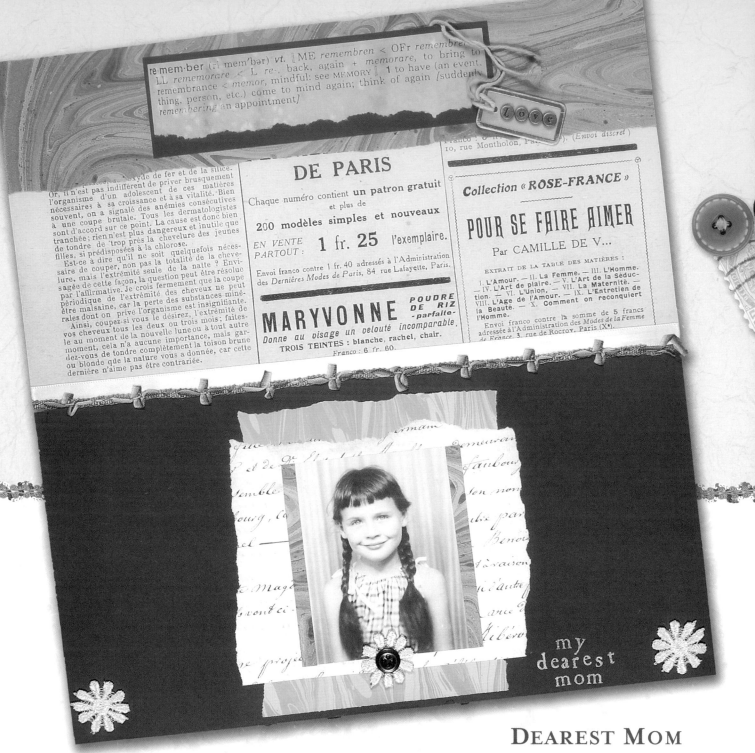

DEAREST MOM
Roben-Marie Smith

MATERIALS:

TAG AND METAL LETTERS: MAKING MEMORIES

ALPHABET RUBBER STAMPS: PSX

INK: STAZON

ADHESIVES: THE ULTIMATE! GLUE; GLUE DOTS INTERNATIONAL

OTHER: BROWN CARD STOCK, RIBBON, BUTTON, LACE, DICTIONARY PAGE AND MARBLED PAPER, FRENCH NEWSPAPER AND SCRIPT

INSTRUCTIONS:

Layer card stock, marbled paper and French newspaper to page as shown. Copy dictionary definition of "remember" onto coffee-dyed paper and tear; glue to strip of card stock and then to top of page. Add ribbon and lace between card stock and French paper. Layer script and marbled papers and photo to page. Glue three lace daisies to bottom of page and black button to middle daisy. Stamp "my dearest mom" with white ink. Adhere vellum tag to top of page; use glue dots to add metal alphabets to front of tag.

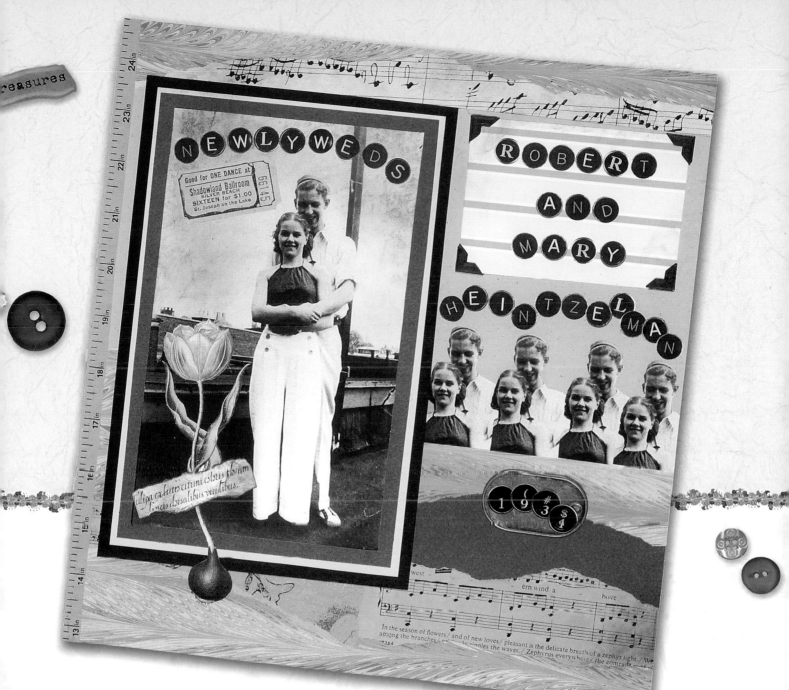

NEWLYWEDS

Joey Long

MATERIALS:

TYPEWRITER LETTERS AND NUMBERS:
NOSTALGIQUES BY REBECCA SOWER

IVY, BISQUE AND BLACK PAPER: CANSON

PHOTO CORNERS: CANSON

COLORED PENCILS: PRISMACOLOR

ADHESIVES: ART ACCENTZ STICKY TAPE;
THE ULTIMATE! GLUE; UHU GLUE STICK

OTHER: PICTURE OF FLOWER,
FAUX DOG TAG, DANCE TICKET,
WHITE SCRAP PAPER, MARBLED PAPER,
SHEET MUSIC AND MEASURING TAPE

INSTRUCTIONS:

Make several copies of newlywed's photo. Mount one to ivy, bisque and black paper. Cut heads and shoulders out of several copies and set aside. Tear pieces of marbled paper, ivy paper and sheet music and mount on page as shown. Computer-generate sentiment, and tear edges. Cut rectangle from white scrap paper and adhere to page with photo corners. Tape main photo onto page, add all sticker letters, the flower, sentiment and dance ticket. Place number stickers (date) on dog tag. Lightly tint parts of the page with colored pencils.

MOMENTS

Roben-Marie Smith

INSTRUCTIONS:

Cut and layer paper and fabrics to page. Make
duplicate of photo and glue a portion of it to
inside of metal frame. Use glue dots to adhere
frame and pewter "moments" plate to
page. Glue photo to page and add metal
photo corners with glue dots. Add vellum
tags with brads and pressed flowers
with glue. Glue trim and lace to page.
Add numbers with glue dots.

[CREATIVE TIP]

*Duplicating a special part of a photo under
a frame creates a powerful visual impact*

MATERIALS:

PATTERN PAPER: 7GYPSIES AND ANNA GRIFFIN

**BRADS, VELLUM TAGS,
METAL PHOTO CORNERS AND FRAME:**
MAKING MEMORIES

**PEWTER "MOMENTS" PLATE AND
NUMBERS:** LI'L DAVIS DESIGNS

PRESSED FLOWERS: LOCAL CRAFT STORE

ADHESIVES: ELMER'S GLUE STICK;
GLUE DOTS INTERNATIONAL

OTHER: FABRICS, TRIM AND LACE

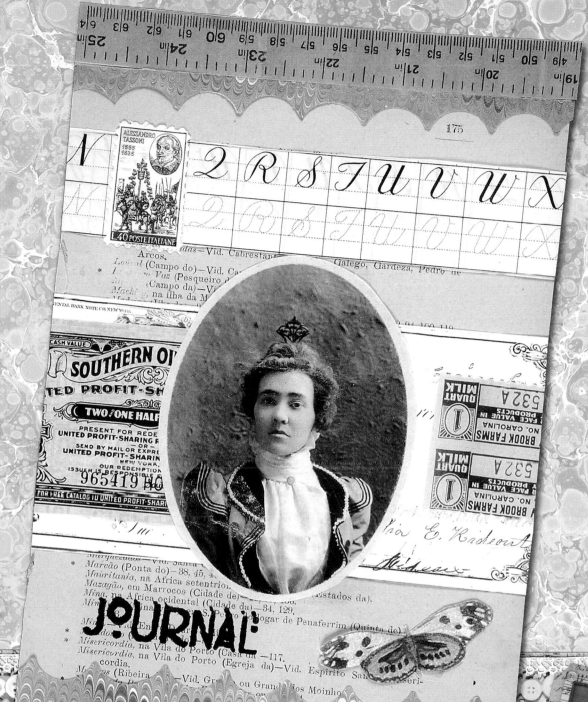

GREAT AUNT MARGARITA

Jill Haglund

INSTRUCTIONS:

Paste coffee-dyed book page as background. Cut two 2" strips of marbled paper. Use decorative scissors to cut a scalloped edge on each strip. Glue the paper yellow ruler to one piece and adhere to top of page as a border. Add the other piece as a bottom border. Adhere penmanship strip to top of page. Glue canceled check in the center of page and layer on certificate and tickets as shown. Tint your photograph, place on card stock, trim and glue to layers. Add butterfly and postage as shown. Stamp "Journal" on bottom of page.

MATERIALS:

MILK COUPON, PAPER RULER AND CERTIFICATE: PAPERBAG STUDIOS

RUBBER STAMP: STAMPERS ANONYMOUS

INKPAD: STAZON

ADHESIVES: THE ULTIMATE! GLUE; YES! PASTE

OTHER: POSTAL STAMP, BUTTERFLY, COFFEE-DYED BOOK PAGE, MARBLED PAPER, CANCELED CHECK AND PENMANSHIP STRIP

JOEVETTA'S FATHER

Joey Long

INSTRUCTIONS:

Glue red paper strip to right edge of page; layer marbled paper as shown. Add torn sheet music to top right corner. Tape envelope to page, then punch with Anywhere Punch; add brads to corners. Use circle cutter to cut circle from red paper; cut photo slightly smaller. Cut slits in shoulders and tuck in wings. Mount photo onto red circle, then to page. Add torn sheet music and glue to envelope. Use ivy paper to make tag to fit into envelope. Glue color copy of old postcard to tag, thread fibers and ribbon through tag hole.

MATERIALS:

MARBLED PAPERS: ANGY'S DREAMS

GOLD ANGEL WINGS: STAMPINGTON & COMPANY

IVY PAPER: CANSON

BRADS: MAKING MEMORIES

SILK RIBBON: JKM RIBBON AND TRIMS

NO. "10" BROWN KRAFT BUTTON AND STRING
ENVELOPE: OFFICE SUPPLY

ADHESIVES: ART ACCENTZ STICKY TAPE; THE ULTIMATE! GLUE; UHU GLUE STICK

OTHER: FIBERS, SILK, SHEET MUSIC FROM AN OLD CHRISTMAS SONG BOOK, ANTIQUE CHRISTMAS POSTCARD, RED PAPER

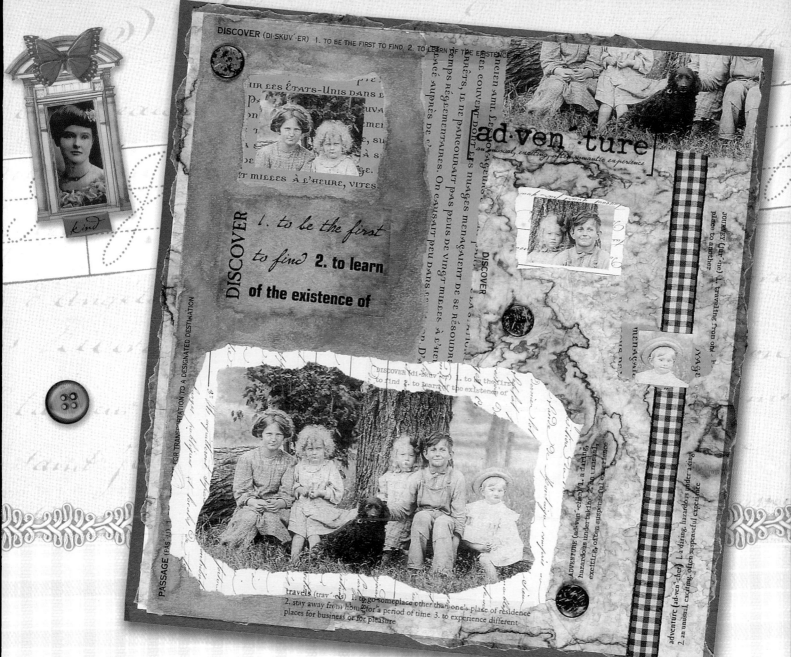

ADVENTURE & DISCOVER

Roben-Marie Smith

MATERIALS:

PRINTED WORD PAPER: THE CREATIVE BLOCK

WATERCOLOR PAPER: FREDRIX

CARD STOCK AND DEFINITION STICKERS: MAKING MEMORIES

TRANSPARENCY FILM: OFFICE SUPPLY

WALNUT INK: ANIMA DESIGNS

ADHESIVES: UHU GLUE STICK; ART ACCENTZ STICKY TAPE; GLUE DOTS INTERNATIONAL

OTHER: GLASSINE PAPER, RIBBON AND OLD BEADS AND SCRIPT PAPER

INSTRUCTIONS:

Copy definition stickers onto a sheet of transparency film and cut out. Stain a piece of glassine paper with walnut ink. Once dry, wrinkle it and glue to card stock. Stain a piece of torn watercolor paper with walnut ink. When dry, tear and tape to page, layering printed word paper behind it. Glue ribbon to left side of page as shown. Layer torn picture to script paper and then to page. Glue copies of the picture to the page. Use tape to adhere transparency definitions to page. Use glue dots to adhere beads.

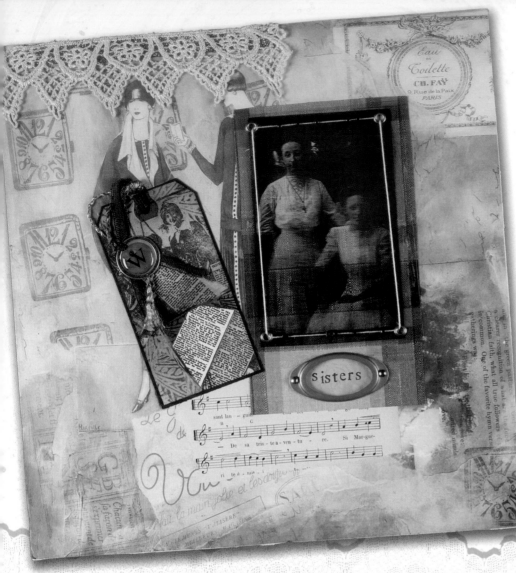

SISTERS
Joey Long

MATERIALS:

PAPER: DESIGN ORIGINALS

RUBBER STAMP: STAMPINGTON & COMPANY

EYELETS, LABEL HOLDER, VELLUM CIRCLE TAG AND LETTER PAGE PEBBLE: MAKING MEMORIES

ALPHABET RUBBER STAMPS: PSX

VARIOUS COLORED INKS: COLORBOX "CAT'S EYE" INKPADS

ADHESIVES: YES! PASTE; ART ACCENTZ STICKY TAPE

OTHER: FIBERS, SCRAP OF WALLPAPER, BEADS, LACE, OLD SHEET MUSIC AND CROCHET THREAD

INSTRUCTIONS:

Paste Design Originals paper onto page. Copy photograph onto transparency and trim. Tape transparency to wallpaper scrap and set eyelets; slip thread into eyelets adding beads on the top and bottom of photo. Pull thread tight and tape to the back of paper and then to page. Tear a small piece of sheet music and paste to page. Stamp "sisters" onto green paper, insert behind label holder and attach to page with brads Tag: Rub Cat's Eye inkpads directly onto tag, stamp with black ink. Stamp image again onto white paper, cut out a portion of the text and paste to tag. Mount tag onto black paper, trim, punch hole and thread with fibers; add small circle tag and Page Pebble. Tape tag and lace to page.

MATERIALS:

GREEN MARBLED PAPER: PAPER PASSIONS

IVY PAPER: CANSON

RULER: K&COMPANY (CUT FROM A 12" X 12" SHEET)

SKELETON LEAF: BLACK INK

OVAL "MEMORIES" AND PEWTER PHOTO CORNERS: K&COMPANY

TAGS: OFFICE SUPPLY (COFFEE-DYED)

ADHESIVES: ART ACCENTZ STICKY TAPE; THE ULTIMATE! GLUE; YES! PASTE; GLUE DOTS INTERNATIONAL

OTHER: BUTTONS, COFFEE-DYED LACE AND NEWSPAPER

INSTRUCTIONS:

First, coffee-dye the lace, tags and newspaper. Position and paste the coffee-dyed newspaper for the background. Cut a 2" strip of marbled paper for bottom border. Cut out ruler from paper and add to bottom of page. Add lace to the top of the green marbled paper border. Cut small square from top left corner of newspaper and mat onto ivy paper; tape back into place. Mat photo onto ivy paper, paste onto page; add photo corners. Place skeleton leaf, butterfly postage and all tags as shown onto page. Dry flat. Add buttons and "memories".

CHERISHED MEMORIES
Joey Long

MATERIALS:

PAINTS: JACQUARD LUMIERE PAINTS

RUBBER STAMP: STAMPINGTON AND COMPANY

SMALL STAR BRAD: PSX

SNAPS: MAKING MEMORIES

OTHER: TWILL, COLORED PHOTOCOPY OF LACE AND PHOTO

INSTRUCTIONS;

Use sponge to rub page with Lumiere Paints. Copy and cut out lace trim and photograph. Rub inks onto card stock, stamp and mount onto black paper, trim and paste to page. Paste cutouts of women and lace. Attach twill with snaps and add small brass star brad as necklace.

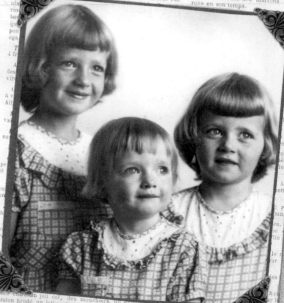

THE KRAEGER GIRLS
Jill Haglund

Product Resource Guide

Scrapbook, Rubber Stamp, Art and Collage Products

First check your local craft store; next see websites for retail store locations nearest you.

- Acey Duecy: Rubber Stamps (PO Box 194, Ancram, NY 12502)
- The Adhesives Products, Inc., Crafter's Pick: The Ultimate! Glue (www.crafterspick.com)
- American Tag: Tags (2043 Saybrook Avenue, City of Commerce, CA 90040)
- Angy's Dreams: Marbled Papers, Stationary, Gifts and Scrapbooks (www.Angysdreams.it)
- Anima Designs: Rubber Stamps and Art Supplies (www.animadesigns.com)
- Anna Griffin: Papers and Scrapbooking Supplies (www.annagriffin.com)
- AW Cute: Scrapbooking Products (www.awcute.com)
- Black Ink Skeleton Leaves: Specialty Papers (www.GPCpapers.com)
- C-Thru Ruler Company: Mini-Additions Tag Template and Scrapbooking Supplies (www.c-thruruler.com)
- The Card Connection: Craft Supplies (Local Craft Store)
- Canson: Mi-Teintes Papers, Scrapbooks, Photo Corners and more (www.canson.com)
- Chartpack: Transfer Pens (www.chartpack.com)
- Chatterbox: Scrapbooking Supplies (www.chatterbox.com)
- Claudine Hellmuth: A Publication titled: "Collage Discovery Workshop," Rubber Stamp Line, Custom Collage Work, Licensed Products, Free Screen Savers and Online E-mail Cards and more (www.collageartist.com)
- Clearsnap: Color Box Inkpads, Cat's Eye, Fluid Chalk Ink, Ancient Page, Petal Point and Vivid Dye Inkpads and Stylus (www.clearsnap.com)
- Coffee Break Designs: (317-240-1542)
- Craf -T Products: Metallic Rub-Ons and Chalks (www.craf-tproducts.com)
- The Creative Block: Rubber Stamps, Papers and Art Supplies (www.stampersanonymous.com)
- Creative Imaginations: Letters, Transparent Stickers, Fancy Eyelets, Shotz, Sonnets, Faux Wax Seals and a full line of Scrapbooking Supplies (www.cigift.com)
- Creative Impressions: Brads of all shapes and sizes and more (www.creativeimpressions.com)
- Deco Art: Paint and Art Supplies (www.decoart.com)
- Duotone: Stabilo Pencil (www.stabilo.com)
- Dymo: Label Maker (www.dymo.com)
- Elmer's: Glue and more (www.elmers.com)
- EK Success: Zig Photo Twin Tinting Pens, Punches, Stickopotamus Products, Sonnets, Scrapbooking Supplies and more (www.eksuccess.com)

- Ever After Scrapbook Company: Paper and Scrapbooking Supplies (visit www.addictedtoscrapbooking.com until www.everafterscrapbook.com is available)
- EZ Laser Designs: Laser Letters, Number and Word Sets (www.ezlaserdesigns.com)
- Eclectic Products, Inc.: E-6000 Craft Adhesive (800-767-4667)
- Fiskars: Paper Cutter, Scissors and Tools (www.fiskars.com)
- Frances Meyers, Inc.: Paper and Scrapbooking Supplies (www.francesmeyer.com)
- Fredrix Paper: (www.fredrixcanvas.com)
- Glue Dots International LLC: Glue Dots (www.gluedots.com)
- Glue by Duncan Crafts: Aleene's Tacky Glue (www.duncancrafts.com)
- Golden: Paints and Gel Mediums (www.goldenpaints.com)
- Green Pepper Press: Rubber Stamps (www.greenpepperpress.com)
- Impress Rubber Stamps: Rubber Stamps, Anywhere Punch, Eyelets and more (www.impressrubberstamps.com)
- Inkadinkado: Rubber Stamps, Inkpads and more (www.inkadinkado.com)
- Iridori Watercolors: Antique Watercolors (www.artexpress.com)
- Jacquard Products: Pearl Ex and Susan Pickering Rothamel Pinata Alcohol Inks (usartquest.com)
- JMK Ribbon and Trims: Hand-Dyed Silk Ribbons (www.jmkribbonsandtrims.com)
- Judi Kins: Rubber Stamps and Diamond Glaze (www.judikins.com)
- Junkitz: Alphabet Buttons and Zipper Pulls (www.junkitz.com)
- K&Company: Papers, full line of Scrapbooking Products, including Life's Journey Vintage Line with Papers, Vellums, Adhesive-Backed Letters and Ephemera, Pewter Letters and Tag Plates and more (www.kandcompany.com)
- Li'l Davis Designs: Trinkets, Pewter Name Plates, Bubble Type, Digits Phrases and Discs (Local Craft Store, or, wholesale only: www.lildavisdesigns.com)
- Magic Mesh: (www.magicmesh.com)
- Making Memories: Punches, Ribbons, Date Stamp, Small Hammer and Mat for Eyelets, Card Stock, Pewter Frames, Page Pebbles, Eyelets, Snaps, Brads, Metal Words and Plates and a full line of Scrapbooking Supplies (www.makingmemeories.com)